Andy Warhol: films and paintings

In 1961 fashionable but unconsidered commercial artist Andy Warhol created an artistic furore in New York with his deadpan versions of the Campbell soup can. Since then he has become the most talked about, least understood artist of the avant-garde.

Warhol has made acceptable the use of industrial 'cold' techniques in the creation of human 'hot' paintings with an obsessive affiliation with uniquely twentieth-century imagery—car crashes, coke bottles; uniquely twentieth-century symbols of sex—Marilyn Monroe, Liz Taylor; and of death—the electric chair, condemned men.

The films force us to *look* at the object/subject; they involve us in Warhol's vision of clinical subjectivity. With such films as *Blowjob, Chelsea Girls* and *Lonesome Cowboys* he has remade the form and content of cinematic experiment and production.

Andy Warhol is a concise and perceptive analysis of a revolution which has brought life back to painting and the cinema back to itself. The 'silver-haired idol of the jet set' is taken at more than the mass-media face value in Peter Gidal's attempt to understand him on all levels, as the film-maker who deals with people as people; and the painter who deals with people and objects as icons of our time.

Peter Gidal is a young American film-maker with twelve films in the London Film-makers' Co-operative. They have been shown at London's New Arts Lab and National Film Theatre. He is currently filming his three-hour 'double feature' and writing a book on English underground films.

Front cover From **** 1966–7

Back cover Andy Warhol 1966
Photo Michael Cooper

Andy Warhol 1966

Photo David Bailey

Peter Gidal

Andy Warhol

films and paintings

Studio Vista | Dutton Pictureback
General Editor David Herbert

To Gyro Gearloose and Watt

'Right now, in this period of change in the country, the styles of Warhol and Castro can be blended. It's not guerilla warfare, but, well, maybe a good term is monkey warfare. If the country becomes more repressive we must become Castros. If it becomes more tolerant, we must become Warhols.' (Abbie Hoffman)

© Peter Gidal 1971
Designed by Gillian Greenwood
Published in Great Britain by Studio Vista Ltd
Blue Star House, Highgate Hill, London N19
and in the USA by E. P. Dutton and Co., Inc.
201 Park Avenue South, New York, NY 10003
Set in 8D on 11 pt Univers 689
Made and printed in Great Britain by
Richard Clay (The Chaucer Press) Ltd,
Bungay, Suffolk

SBN 289 70073 6 (paperback)
 289 70074 4 (hardback)

Contents

Chronology

Andy Warhol was born in Philadelphia in 1930. He studied at Carnegie Institute of Technology and has lived in New York City since 1952.

1960 : Comic-strip paintings, abstract-expressionist style.

1961 : Early fruit tins; Coca-Cola labels; bottles; newspaper front pages; dancestep diagrams; soup cans.

1962 : Multiple-image cokes; stamps; do-it-yourself paintings; *Soup cans,* also many pencil drawings of soup cans, crushed, stacked, full, empty, with dollar bills flowing from the top, etc.; also involved with size (some of the soup cans five inches high, some six feet); early *Marilyn* paintings; serial images (silkscreens and silkscreen plus handpainting additions); early heads of *Elvis; Liz; Texan* (early version of *Rauschenberg* narrative painting). First one-man show, Ferus Gallery, Los Angeles; Stable Gallery, New York.

1963 : *Death and Disaster* series: car crashes, lynchings, suicides, accidents, etc.; *Most Wanted Men* series. Second one-man show, Ferus Gallery, Los Angeles.

Began making films: *Kiss, Haircut, Eat, Blowjob, Sleep, Tarzan and Jane Regained, Sort of. . .*

Films shown at the New York Film-makers' Co-operative and at the Cinémathèque.

1964 : Early soup can cartons, Brillo boxes, Motts' Apple Juice and Kellogs' Cornflakes cartons; *Flower* paintings; race riots; multiple and single-image self-portraits; started *Jackie* series and large full-scale *Elvis* paintings; continued various portraits of *Marilyn, Liz,* etc. One-man show Ileana Sonnabend gallery, Paris; Stable Gallery, New York; Leo Castelli Gallery, New York.

Films: *Batman/Dracula, Empire, Couch, Henry Geldzahler, Shoulder, Mario Banana, Harlot, 13 Most Beautiful Women, Salome and Delilah, Soap Opera, 13 Most Beautiful Boys, Taylor Mead's Ass.*

1965 : Continued *Jackie* paintings, self-portraits, *Marlon Brando,* etc. One-man shows, Enzo Sperone Arte Moderna, Turin; Ileana Sonnabend Gallery, Paris; Rubbers Gallery, Buenos Aires, Argentina; Buren Gallery, Stockholm; retrospective Institute of Contemporary Arts, Philadelphia.

Films: *Suicide, Screen Test No. 1, Screen Test No. 2, Life of Juanita Castro, Drunk, Horse, Poor Little Rich Girl, Vinyl, Bitch, Restaurant, Kitchen, Prison, Face, Afternoon, Beauty No. 2, Space, Outer and Inner Space, My Hustler, Camp, The Shopper, Closet, More Milk Yvette, Eating Too Fast* (sound version of *Blowjob,* different 'actor').

1966 : Series of self-portraits from Rudolph Burkhardt's photo-
graph. One-man show Leo Castelli Gallery, New York;
Enzo Sperone Arte Moderna, Turin; Neuendorf Gallery,
Hamburg; Contemporary Art Center, Ohio; retrospective
Institute of Contemporary Arts, Boston.
 Films: *Chelsea Girls*; segments of * * * * (*Four Stars*).
 Mixed-media light-film-sound environment, with the
Velvet Underground Rock Group featuring Nico as
chanteuse.
1967 : One-man show Ileana Sonnabend Gallery, Paris; Zwirner
Gallery, Cologne. Exhibition at Leo Castelli Gallery, New
York, of one room papered with *Cow* wallpaper, second
room with silver floating pillows (*Clouds*).
 Films: *I, a Man, Bike Boy, Nude Restaurant.*
 Brought out *Andy Warhol's* (*Index*) *Book* with foldouts,
balloons, record, etc. Also, with Gerard Malanga's poems,
the book *Screen Tests: a Diary* (stills from film-portraits of
friends and personalities). Alan Midgette, a 'double', sent
on 'Andy Warhol lecture tour'.
1968 : One-man shows, Rowan Gallery, London; Kunsterhus,
Oslo; retrospective Moderna Museet, Stockholm.
 Film: *Lonesome Cowboys.*
 Brigid Polk, friend and assistant, made series of silk-
screens 'by' Andy Warhol, *Flash, Nov. 23, 1963* on
Kennedy's murder; later set of screens *Slash*. New Brillo
boxes (made by another friend?). Set of ten silkscreens of
Marilyn (ten colour variations), also set of ten *Flowers*
(ten colour variations) made by another friend (apparently
using Warhol's stencils, perhaps he even chose the colour
variations)?
1969 : Première of *Fuck* (*Blue Movie*) at the Andy Warhol
Garrick Theatre, New York, busted by police after three
weeks. Eight-hour film *Imitation of Christ,* previously a
segment of * * * *, also exists as two-hour film.
 Schraffts' ice-cream commercial for TV; airline commer-
cial. First novel, *a.*
1970 : Retrospective Pasadena Museum; Institute of Contempor-
ary Arts, Chicago; Stedjelik Museum, Eindhoven; Musée
d'Art Moderne, Paris.
 Second novel, *b.*
1971 : Retrospective Tate Gallery, London; Whitney Gallery,
New York. (Warhol wanted *Cow* wallpaper hung back-
wards in every room, nothing else, 'something new'.)

Andy Warhol 1966
Photo Michael Cooper

Andy Warhol

'I think it would be terrific if everybody was alike.' Andy Warhol is an enigma, partly because his art and his person are difficult to understand through conventional modes of criticism and insight. His father was a labourer who died when Andy was nine years old. 'I have a lot of southern themes in my paintings. Flowers and Liz Taylor and bananas, which all the monkeys down there eat. Yes, I have used negroes in my painting. The negroes are a vital part of the South. In fact, if it weren't for the coloured people in the South, my father's refrigerator factory would close down.' Warhol was the middle brother of three, and according to his own admission was the subject of nervous breakdowns, 'the doctor called them St Vitus' Dance. I ate so much candy. I was weak and I ate all this candy.' Andrew Warhola (or Andrew Warholl, as he later called himself during his fashionable shoe-design period for *Harper's Bazaar, Industrial Design,* etc.) lives with his mother in a town house in New York's East 80s. She occasionally paints and signs herself 'Andy Warhol's mother'.

It seems more and more a self-destructive impulse of the mass media to concentrate on asking Warhol loaded or just plain stupid questions about his art and his life, for his answers only serve to baffle all the more those who (consciously or not) are being provoking. 'The interviewer should just tell me the words he wants me to say and I'll repeat them after him. I'm so empty I can't think of anything to say. I'm not more intelligent than I appear. I'm not really saying anything now. If you want to know all about Andy Warhol, just look at the surface of my films and paintings and me, and there I am. There's nothing behind it.' According to one close friend, 'Apparently he wants kids. His brother's kids were here and he loved them. But I think he lives in his head a lot.' Most people who've had dealings with Warhol on a close level feel that he is shy, sensitive, tender, and at the same time (obviously) extremely strong-willed as an artistic force. A friend from his days as a painting student at Carnegie Tech says, 'He was the most shy, uncommunicative, reticent, non-verbal person . . . but absolutely extremely gifted, the only truly *intuitive* artist I've ever known in my life. He could not do anything wrong in his work, really, and he could never explain why.' He was attacked and shot by Valeria Solanis (who played a part in his

film, *I, a Man*) in June 1968. After that he was out of circulation for a while. The mass media made mincemeat of him; that night he was on the fifty/fifty critical list for nearly six hours, dying, one of the Group W (Westinghouse) television stations in New York City could only make obscene grunts, ' . . . if he recovers, we'll find out it was one big pop-art joke, and Andy'll be laughing all the way to the bank.'

The viciousness of the press revealed the traditional hatred by the mass media of that which they do not really understand but which nevertheless makes sensational copy (and sells papers, and keeps the viewers awake). Sensationalism mixed with puritan condemnation was brought out in full force. When Warhol returned after his wounds healed (although never completely, to this day), he said, 'I've been thinking about it. I'm trying to figure out whether I should pretend to be real or fake it. I had always thought everyone was kidding. But now I know they're not.' Asked how he felt about Valeria Solanis he answered, 'I can't feel anything against her. When you hurt another person, you never know how much it pains. Since I was shot, everything is such a dream to me. I don't know what anything is about. Like I don't even know whether or not I'm really alive or whether I died. I wasn't afraid before. And having been dead once, I shouldn't feel fear. But I am afraid. I don't understand why.'

Often it is difficult to break the camp façade that Warhol puts up; were one extremely close as a friend, one would not be writing a book. At the same time, any distance from Warhol at all makes the mass media intrusion more influential than it should be. At the old Factory, before he moved, the atmosphere was extremely casual. In the States more than anywhere else, paranoid convictions of persecution are not delusions; they're real. The Warhol uptightness about drugs being used at the Factory is warranted, because the place is constantly watched and raided for orgies, freak-outs, junk, etc. At the Factory, Fred Hughes, Warhol's young soundman, approaches shyly, talks openly without fear of being put down, without defensiveness. The aura of the place is so different from one's preconceived notions that one can only react with disgust to the media misconceptions and obvious

Andy Warhol 1966
Photo David Bailey

Andy Warhol 1967
Photo Peter Gidal

Andy Warhol 1969
Photo Cecil Beaton

distortions, the same way one reacts to American, English, and French (et cetera) television calling the Cambodian and Vietnamese people 'the enemy'. Personal and political attitudes are closely related.

For Warhol, everyone is a star; or at least more nearly 'everyone' than for anyone else. The people he chooses, just like the images he chooses, are relevant, important, meaningful because of the essential rightness of his choice; it just feels that way. He demythologizes the taboo: lesbians, homosexuals, hustlers, pushers. The world he works with is the world he can communicate with, the world most of us have been unable to communicate with. Or else we communicate with it in a paternalistic, 'liberal' fashion.

Warhol's people (friends) seem less hung-up than we do because they live out their fantasies and drives openly with each other, while we repress them.

In his silkscreen work, the images he communicates to us are car crashes, deaths, and 'stars': all images which we have relegated to meaninglessness, either through lack of recognition or over-indulgence. He's managed to re-expose us to what we thought was either irrelevant or over-used.

An artist must be judged by his art, but Warhol's art and his person are closely linked. The contradictions of his life fit the contradictions of his art, and vice versa. Elements of the blurred border between the serious, the pathetic, and the put-on and the put-off, exist in both.

Whether an idea came from a friend (to paint money, soup cans, disasters) or from himself (stars, coke bottles), it's a matter of the whole being more than the sum of the parts. Utilizing the idea 'Campbell soup can' which someone else has brought to his consciousness, relating to that and then creating the art image, has to do with the making of a whole. The way in which it is presented (expressionistically, minimally, etc.) is another decision made towards the definition of the final art product (here a friend preferred the straightforward rendering of the coke bottle to the brush-stroked one). Utilizing the silkscreen process for presentation of the final image (coke bottle, soup can, green stamps, money) is a factor; so is the intuitive choice to serialize the images. The sum total of conscious and unconscious choices creates a quantity which qualifies each work of art. Jasper Johns' light bulbs may have been one impulse inspiring Warhol to common object portrayal, but then so may Rembrandt's famous 'old worn shoes' painting have been. Duchamp's use of serialization in designating as 'art' the found object (often mass-produced) may also have been an influence. Or maybe it was not. Richard Hamilton's 1956 collage, *Just What Is It That Makes Today's Homes So Different, So Appealing,* may have been an assimilated influence. Henry Geldzahler suggested that Warhol paint the *New York Mirror* front page *'129 DIE'*. This suggestion to *paint* a disaster changed to 'painting' disasters through the silkscreen process which includes the abstract-expressionist focus on chance. The product of various sensibilities was refined and made whole by Warhol's personal creativeness. Feeling critical about his having experienced many converging influences is just another barrier imposed by our traditional ways of accepting creative originality. Some people encounter similar barriers when they realize that Warhol's movies are largely unscripted, often with only the slightest

Fred at the Factory 1967
Photo Peter Gidal

15

Sally at the Factory 1967
Photo Peter Gidal

'direction' given by Warhol; some find it difficult to accept that many of his best and most original and important film works had little involvement on his part other than the initial idea and the 'set', the rest having been left to the instinctive, momentary impulses of the 'actors'. Warhol is. There are two ways in which one can reach his work. One can come into contact with it, react, and allow one's sensitivities to take it in, mettle with it internally, come to grips with what is happening *there,* and come out the other end, the encounter transmuted into experience. Or one can allow one's intellectual backlog to deal with the work, permit words, random notes, interviews, fleeting media-orientated encounters with Warhol to surge through the brain, thus coming to grips through a verbalized version of and reaction to his work. The real digging-in, in this latter case, follows the preconceptions and their possible reorientations. In all probability, the two modes of perception do not exist as choices anyway. The influx of impulses worked through convoluted media distortions, leads to outright manipulation of one's response faculties. The social/political orientation of *now* is such as to disallow pure experience.

This book is by its very nature one person's subjective coming-to-grips with Andy Warhol's work. As such, it can only attempt to involve itself as fully as possible in the work and in the individual *process* of response to the work. The outcome must (and will) be a reorientation, but at the same time, each individual will by necessity translate this experience into, hopefully, a *subjective* impulse towards a more personal responsive mechanism in dealing with the work. In order to avoid the deadly influence of 'peak-experience' orientation (goal-seeking its rationale), any positive statements about Warhol's genius as an artist should be taken not as intended to conjure idolatry, but as open space for shared experience. The ultimate insight into experience is always personal, and *that* this book does not attempt to mitigate. Just as when Norman Mailer says 'Warhol's the worst but most importantly influential artist alive', that is his opinion, so this book is my opinion.

Paintings

One can speak of Warhol as having been a painter, although, strictly speaking, he mostly silkscreened his images and then, sometimes, would 'touch-up' the finished pictures by hand. Previous to this period of 'paintings', Andy Warhol was involved in making drawings (pencil, crayon, etc.) of what are now commonly known as pop objects (soup cans, dollar bills, Coca-Cola bottles, comic strips, etc.).

The evolution of Warhol's involvement with popular iconography was first made publicly noticeable through his first one-man show in 1962. By this time he had not only begun the pop images but had also experimented with the serial in art. He became interested in the emotional and intellectual impact caused by repetition, whether created on one single plane or not. At first, therefore, the repetitious elements were made clear through his drawing and painting the same objects in different ways. Later, the repetition obsession became more subtle in that a single work would have many exact copies of the same basic image, although each impression (upon the same canvas surface) would *look* different, owing to the pressure applied when the image was being silkscreened down, and the position of the screen, since all the work was done by hand and variation was common.

The variation that thus took place was based largely upon technical necessity. Not having an automatic machine with precision adjustments, there was no choice but for the human hand to 'err'. Warhol has made artistic use of precisely the human-physical in the art act, even when this act was as media-orientated as the transferring of a silkscreen image. After all, the initial picture was merely chosen by the artist from a newspaper or from some common image. A silkscreen was technically prepared by someone completely absolved from making any artistic, aesthetic decisions. Only then did the artist come in contact with the screen, from which to print his 'painting'. The technical happenings involved in the silkscreen process are now decisive: how does Gerard Malanga (Warhol's early friend and assistant) hold his end of the screen frame; how hot a day is it today and how much pressure does one therefore apply when rubbing, over and over again, the black screen ink through the pores of the silken image; how many prints will be made and in what colours; how cold or

From *A Gold Book* (undated, about 1962)

hot is it, as this affects the drying potential of the ink on paper (or canvas), etc. These seemingly haphazard questions that are part of the technique of making an art product become of paramount importance since they make the changes inherent in the *process*. Warhol has conceptually understood that the differentiation from one image to the next is more important for the fact of its differentiation than for the specific differences manifested (lighter, darker, thicker, etc.). The McLuhanesque 'medium is the message', discovered years before by the abstract-expressionist action painters, was now utilized by Andy Warhol in the silkscreen process of painting. He was tuned in to the possibilities inherent in the medium he was using—a sensitivity without which there can be no good art. Time and time again Warhol discerned that the results of a process could shape infinitely more than a stilted gimmicky, 'arty' involvement by the artist. He chose to allow the medium to become part of the message, and as we shall see later on, upon selection of process and images rests Warhol's genius. Painterliness as such proved to be unimportant.

Warhol has been concerned, in the field widely defined for our purpose as painting, in various thematic endeavours; serial imagery (and repetition within each individual picture); fauvist use of colour (applying seemingly arbitrary colour substitutes so as to have, for example, eight self-portraits or soup cans each with different multiple colours; a process which enhances the arbitrary nature and alienation of the object); the portraits of stars (self-portrait, Marilyn [Monroe], Liz [Taylor], Elvis [Presley], Jackie [Kennedy], etc.). Here already there are several overlapping themes, since his portrait pictures are in part from the *Death and Disaster* series done in 1962 through 1964. Some of the images from the *Death and Disaster* series were manipulated in a serial manner, which places them within that category. Furthermore, almost all of Warhol's images have been treated to colour variations. Another common factor was his abstract-expressionist line and colour in early drawings and paintings, and the application of the silkscreen (brushmarks, scratches, errors, erasures, corrections, scribbles, etc.). Clear-cut categorization is impossible, for we can find elements of *all* his thematic preoccupations in *all* of his works. I will now attempt to discuss his major thematic concerns.

In the early sixties, the Campbell's soup cans caused a rage, because of the *content* they represented. The banality of the

Dick Tracy 1960, casein on canvas, $70\frac{1}{8} \times 52\frac{1}{2}$ in.
Red Carpet Gallery, New York

image which Duchamp in his readymades had 'invented', had still not sunk into the acceptability capacity of the (mass) audience. Thus the shock. At first Warhol was *using* an image, partly for other purposes. If he drew soup cans with green dollar bills by the hundreds overflowing from them, there was an overt message in this. When Warhol painted a hardcore metal soup can with the label crumbling and tearing off, it was in the firm tradition of representational/symbolic art. The symbol of a consumerized society peeling off to expose the hard, ugly core can only be understood in one way. But Warhol, who left such expression(ism) after some time, went on to minimalize the image to its flat-space potential: he ended up silkscreening the label of a soup can under the drawn image of the top perspective view of a can. He was working out an uneasy compromise of three-dimensional space and two-dimensional space. What for the abstract expressionists was so important, the utilization of flat surface canvas for what it actually was, a non-3D space, was achieved by Warhol's flat soup can wrapper, portrayed as such. At the same time the traditional concern with illusionistic space was evident; to produce this effect without artistically 'cheating', Warhol handpainted (or screened a handpainted stencil) for the top lid of the can, which recedes backwards into a false space. (The soup cans aren't quite as academic as they sound. Having been screened with day-glo reds, yellows, and purples, they become mesmerizingly three-dimensional in 'black'—ultra violet—light. The drug culture in the middle/late 1960s was experimenting with hallucinatory posters; Warhol's soup cans are flashy, brash, and look like a fantastic vision out of the psychedelic supermarket. The visually vibrant soup cans are a parallel to the drug experience, giving life to even the dullest, or least obvious, objects. Incidentally, the use of primary colours rather than 'art' colours was another innovation brought about through Warhol's early soup cans; the fact that the primary colours were originally used by the Campbell's packagers themselves made it no less a tough stance artistically for Warhol.)

Having thus integrated two visions of artistic possibility, Warhol continued to explore the image for its own sake, what later became known as a minimalist viewpoint: to present the *thingness* of a thing and confront the viewer with that, rather than with any implicit or explicit content. In so doing Warhol stumbled on to an obsessive repetitiveness which was astounding

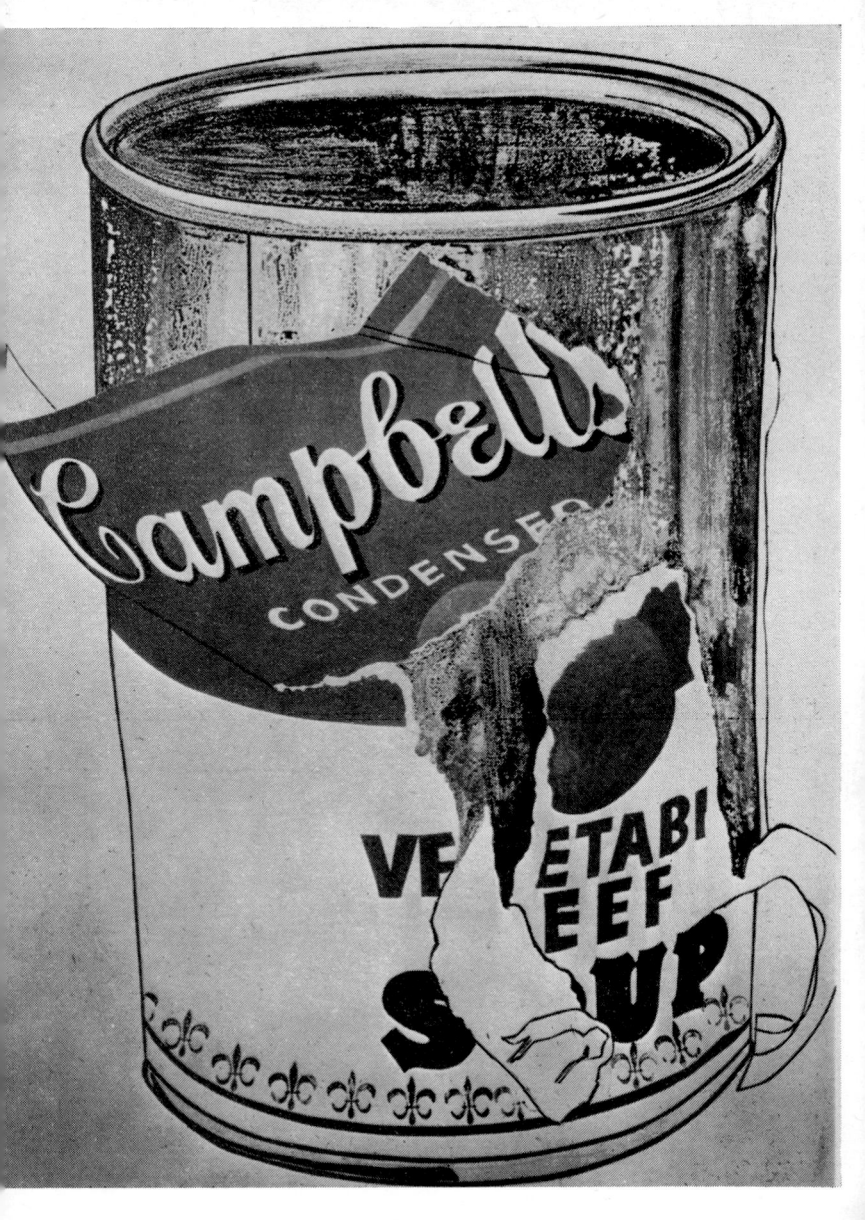

Campbell Soup Can with Peeling Label 1962, acrylic and silkscreen
enamel on canvas, 72 × 54 in.
Private collection

32 Soup Cans (left panel) 1961–2, acrylic and silkscreen enamel on canvas, each panel 20 × 16 in.
Irving Blum Gallery, Los Angeles

6 Campbell Soup Cans 1964, mass-printed labels, $3\frac{1}{2} \times 2\frac{1}{2}$ in.
Collection Heinz Beck, Düsseldorf

for its attack on the sensibilities. One was not ready to be attacked by a 'content-less' image, much less by one repeated fifty times over. Duchamp responded correctly when he said, 'What interests us is the concept that wants to put fifty Campbell soup cans on a canvas.' The conceptual possibilities are important, Warhol's art from the beginning working on many levels, from the purely visual to the content-orientated (thus social/critical), to the conceptual. In the last, one can actually *feel* one's response to the artwork almost as well by thinking the artwork as by encountering it. When Warhol thinks of fifty soup cans as a confrontation, we establish our *selves* in relation to that *thing*. In the same way, we establish ourselves in relation to the otherness of a floorpiece by Carl Andre or two parallel chalk lines in the Mojave desert by Walter de Maria. The Campbell soup cans remain the hardest of Warhol's works to come to terms with because they still seem so meaningless, and this is a challenge in a world where every fifth rate television show claims for itself universal truths and (melo-)dramatic importance. Relating to minimality is what Warhol is concerned with. Warhol has taken a Beckettian sensibility to his manipulation of the common image.

The repetition of the image leads to exciting moments which are unanticipated in the pure concept of the piece. The differences brought about by the handling (technique) make smudges, colour variations, etc., of importance. By thus illuminating the small moments, Warhol escaped from the gutter of obvious meaning in large statements (which the abstract expressionists were so concerned with) and found for himself a niche which in its alienated subtlety is second to none. The mass response to his work suggests a misunderstanding of his acute sensibility. The mass media were bound to play up the camp elements, or what could be taken as such. Warhol does not fight this attitude, in fact, he seems on the one hand to enjoy the publicity (don't we all?), and on the other, to be so alienated from existence, so sick of trying, that seeming passivity is the only answer. He thus masochistically creates an art which can appeal to the levels of intelligence which for him are such a frustration while at the same time it allows him to express his artistic vision with a no-compromise attitude that his fellow-artists have not been able to reach. 'I want to care but it's so hard.'

Green Coca-Cola Bottles 1962, acrylic and silkscreen enamel on canvas, 83 × 57 in. Whitney Museum of American Art, New York

Two-Dollar Bills 1962,
silkscreen on canvas,
$82\frac{3}{4} \times 37\frac{3}{4}$ in.
Collection Peter Ludwig,
Wallraf-Richartz Museum, Cologne

Plane Crash 1963,
oil and silkscreen on canvas,
$100\frac{1}{4} \times 71\frac{5}{8}$ in.
Collection Peter Ludwig,
Wallraf-Richartz Museum. Cologne

'When you see a gruesome picture over and over again, it doesn't really have any effect.' The question is whether Warhol is making this statement in his serial paintings (of 'death and disaster', for example), or whether he is denying it. Perhaps he is giving us the total process, from involvement to non-involvement, thus presenting the emotional equivalent of the actual experience of twentieth-century awareness: the linear attitude from strong

FINAL ★★ 5¢

WEATHER: Fair with little change in temperature.

Vol. 37, No. 296

New York Mirror

MONDAY, JUNE 4, 1962

C

129 DIE

(UPI RADIOTELEphoto)

IN JET!

Car Crash 1963, acrylic and silkscreen enamel on canvas, 96 × 72 in.
Los Angeles County Museum of Art, gift of Leo Castelli Gallery and
Ferus Gallery

◀ *Saturday Disaster* 1964, acrylic and silkscreen on canvas, 60 × 82 in.
Rose Art Museum, Brandeis University, Massachusetts

White Disaster 1963, acrylic and liquitex on canvas, 106 × 82 in.
Collection Karl Ströher, Hessisches Landesmuseum, Darmstadt

reactive sensibility towards fear symbols such as car-crash victims, the bomb, the electric chair, race riots, to a distancing through repetitiveness. The quality of the experience through Warhol's presentation is in its ability to take us to beginnings, since the strength of the image and the way he sets it up for us gives it, each time again, some of its primal shock-power. Thus

35 Jackies 1964, acrylic and liquitex on canvas, 100½ × 110¾ in.
Collection Karl Ströher, Hessisches Landesmuseum, Darmstadt

we are neither wholly presented with a statement about 'repetition
ruins effect' nor are we made to feel that repetition enhances
effect. In fact we are made to experience the evolution (devolu-
tion) from initial shock and intensity of feeling to an alienated
separatedness, a distancing.

In his serial painting Warhol does not use conventional filmic
continuity, linear, chronological progression. The differences of
image within one painting (*35 Jackies,* 1964, *Marilyn*, 1962) are
due not to a movement forward in their (Marilyn's, Jackie's, etc.)
real time, narrative time. The changes are due to Warhol's real

33

time (the change in hand-pressure while screening; mood; unconscious posture; movement of the wrist, etc.) when reprinting the same image at (by necessity) successive moments in time. In utilizing this silkscreen process in the *Death and Disaster* series (*Saturday Disaster,* 1964, *Electric Chair,* 1965, *Race Riot,* 1964, *Suicide*, 1963), there is another problem, a moral one.

The ultimate cynicism is in portraying death as aesthetically pleasing. Goya, Genoves, Bacon do the same, but one is less conscious of the duality of one's response; the media-image intrusion in Warhol allows for this awareness, a 'hot' happening seemingly 'coolly' done. There's no easy identification as with Goya's *Execution of Rebels.* By not involving an *obvious* hand-touch sensibility, Warhol is forcing a system to its logical/ultimate conclusion. It is precisely the shock of awareness that Warhol's images bring which denies the common interpretation of him as a pure camp figure, an uninvolved pop artist, an image-maker with no concern. But it is manifestly absurd and useless to try to foist upon image choices so obviously important as Warhol's a traditional liberal tear-jerking sentimentality. (Everyone knows that Goering loved dogs and children. And ?)

So it goes with the *Electric Chair* pictures of 1965 and similarly, but more subtly, the *Green Disaster* of 1963. With respect to the *Electric Chair* image, there is a haunting beauty in the spectral silence that it invokes on its own as an abstract presence, without external references. (The electric chair was implemented more commonly than it is now, with less chance of successful appeal; one result of the many recent successful appeals is to allow the police and the FBI to make certain that no appeal will be even requested, as in the case of the twenty systematically murdered Black Panther leaders.) With the many political references and implications that the electric chair invokes, it is a mysterious and at the same time all-too-obvious image (symbol). The dialectic between beauty and truth toughens, with the ultimate situation in life, death, confronted by the aesthetic imagination's response to the evocative image. The moral dilemma of the

Green Disaster 1963, acrylic and liquitex on canvas, 105¼ × 79⅛ in.
Collection Karl Ströher, Hessisches Landesmuseum, Darmstadt

Electric Chair 1965, acrylic and silkscreen enamel on canvas, 22 × 28 in.
Leo Castelli Gallery, New York

Death and Disaster pictures is at its apex here. To make the
problem even more difficult, Warhol has created a series of electric
chairs in dark blues and reds, which are all the more emotive in
that the colours used are not synthetic glares but rather warm
tones. The 'matter-of-fact' presentation that we are used to with
Warhol is, in these pictures, manipulated so that we feel in no
uncertain terms where the image-maker is at. The *presence* of
emptiness, nothingness, is visible, immediate. And the sign on
the right of the picture plane, 'Silence', is the first (perhaps the
only) literal conception of non-verbalism. The word 'silence' is
taken in on an unconscious level, at the very basis of linguistic
understanding. It is as if the letters s-i-l-e-n-c-e actually were an

Race Riot 1964, acrylic and silkscreen enamel on canvas, 30 × 33 in.
Leo Castelli Gallery, New York

image of silence in their own right. It is no coincidence that the aesthetics of silence had been also taken up by people like Cage, Pinter, Beckett, Nauman, and analysed in terms of intra-cultural definitions by Susan Sontag. As usual, the immediacy of a Warhol-chosen image has hit the centre of a communal nerve. The word's power for creating feeling has not again been so strongly expressed, and the paradox that the emotive power of language is delineated through the word 'silence' (non-word) makes the experience all the more intense. Warhol, in small images, gives the intelligence and the heart so much to work with, one can only try to surmise what sensibility it is that touches such a deep and communal reaction.

The common misunderstanding that Warhol actually avoided hand-touch sensibility is true only in the sense that he *subdued* melodramatism from work of an important nature. What Warhol really did, though, was to put hand-touch *back* into the machine-made product, the multiple object, the repetitive (after all, advertising posters are largely silkscreened). Thus repetition is no longer a compulsive neurosis, obsessive as it may be, but rather a search, subtle and intense, a probe. At the same time, the anti-art statement implied in the gesture of a repeated image is not to be underrated: he's not *asking* for precision of vision, he's saying 'you'd *better* look a lot closer, or else'. The analogy to Jost's fascist statement 'When I hear the word "Culture" I reach for my gun' isn't so far off, only here Warhol wisely realizes the anti-heroic/tragic implications, that the gun will be reached for, is being reached for. His *Death and Disaster* series incorporated lynched negroes and car accidents in the racist South of the USA; car accidents in the racist North *and* South, electric chairs, Liz Taylor during her near-fatal lung operation, Jackie after Jack Kennedy's death, Marilyn after her suicide. Why would someone put these images up for recognition? Why indeed. 'The death series I did was divided into two parts, the first one famous deaths and the second one people nobody ever heard of, and I thought that people should think about them sometimes: the girl who jumped off the Empire State Building or the people who get killed in car crashes. It's not that I feel sorry for them, it's just that people go by and it doesn't really matter to them that someone unknown was killed . . . I still care about people but it would be so much easier not to care, it's too hard to care.'

As to its being easier 'not to care', the flower pictures of 1965 *seem* to be the prime example of the camp attitude. To use the gauche and garish and enjoy it, one must relegate 'taste' and other such considerations to the garbage dump. One needn't be frightfully ivory-towerish about taste, since it all comes down to personal preference (and some people prefer 'better' than others, for a number of questionable reasons). But relegating Warhol's *Flowers* to the camp category is doing them (and him, and oneself) a disservice. Making something that by conventional 'art' standards is deemed ugly into something that by (new) conventional 'art' standards can be seen as beautiful is not the same

Flowers 1965, silkscreen on canvas, each image $14\frac{1}{4} \times 30$ in.
Private collection, London

thing as framing little Swiss postcards above the mantlepiece. The sensibility that makes gaudily coloured flowers beautiful is the same sensibility that allows Liz Taylor to be beautiful underneath the synthetic chemical colouring of the stencils. The question is : what is the motive, and does it work ? One accepts the flower pictures within one's taste even though beforehand one had the fine-art sense to dislike their cheapness. Cheapness connects to a way of seeing beneath surfaces ; and what better way to go beneath the surface than to point it out, to colour it garishly. Cheapness also goes with the price : ten dollars for an art object (when they were first brought out, in a limited edition of 300). It's as if Warhol had managed to make 'city flowers' out of real flowers, and that is part of his aesthetic ; broadening the range of acceptability. By taking a basically cheap-looking image and presenting it (Duchamp's influence, again) he forces it into a category that it was not originally destined for. The original flower image was in some glossy magazine : now it is art. Once it has reached that 'status' position, it confronts the viewer and demands to be looked at more intensely. This search may lead to the following realization : there are four flowers ; if one looks closely one can see that two are male, two female, and it is the two female who are almost touching. The sense of nearness and separatedness, of tension before touch, is brought out even in as basic an image as the picture-postcard-like *Flowers*. The flowers are made two-dimensional by Warhol's colouring and stencil. They become abstract shapes swimming in a tight picture frame. There's a density in spite of the light, colourful spirit of the picture ; a closed-in feeling, a claustrophobic sense beneath the superficial level. And one questions again : why are two touching (just barely), the other two not ? One reads into the picture. Everything is metaphor. Every word, every image, every shape. The point here is that content is always expressive of another content (be it a more, or a less, abstract one). This, in intellectual terms, is what *Flowers* is (can be) about. The conceptual interpretation is one aspect of the total emotive art product. Personally interpreting a work is precisely what art is about anyway ; Warhol here merely takes it all the way.

Warhol utilized the concept of time so strongly that one could easily predict his involvement with film. Critics commonly consider *Robert Rauschenberg* (1963) to be his only narrative picture. Two other works, *Jackie* (1965) and *7 Decades of Sidney*

Robert Rauschenberg 1963, acrylic and silkscreen enamel on canvas,
82 × 82 in.
Collection Abrams family, New York

Janis (1967) are narrative in that their anti-narrative takes precise
consideration of narrative structure and then goes against it. To
see his work as non-linear would be to misunderstand Warhol's
intuition that the viewer responds to a painting in a narrative,
linear way. Warhol's chronological disruptions are geared pre-
cisely to the linear, narrative sensibility with an intent to shock.
And that shock, that dislocation of time that is sensed, forces the
viewer to rework his conscious reactive attitudes. It forces the
viewer into a confrontation with the reactionary concept of time

41

7 Decades of Sidney Janis 1967, synthetic polymer paint silkscreened on eight joined canvases, $16\frac{1}{4} \times 32\frac{1}{4}$ in.
Collection Harriet and Sidney Janis, New York

as goal-orientated. (This finality orientation is much closer to a human death-wish than any of Warhol's so-called passive, death-obsessed asexual predilections. It would be too easy to allow the stock response towards Warhol as a weak, shallow, camp type to survive. Upon such generalizations rests most of his mass-media publicity, and the sickness of the society implied in the sensationalist aspects of these clichés is recognizable. His strength of imagery bound up with the toughest reductive position of any artist makes his mystery all the more complex.)

The *Robert Rauschenberg* picture is the only *obviously* conventionally narrative picture. Confronting the *Janis* or the *Jackie* is all the more important for their *disguised* connection to narrative. Moving top row left to right, then bottom row left to right, we are left to make order of the shocking chaos. But as it turns out, the variations of emotional impression made by the separate blocks of the *Janis* end up denying the need for a fitted chronology. Similarly, a man's life is not reflected by photographs taken professionally, nor by homemade pictures . . . Warhol is looking for a totality and in creating a life from eight images he has culled

the *7 Decades of Janis* in a tight objective manner. This objectivity does not imply that the images themselves are disinterested. It means that one can react as one wishes to an obvious pose by Janis with his two sons in the upper left-hand corner. Equally one can react to the highly introverted and photography-orientated picture further to the right. The last images on the top and bottom rows are the most deadpan, probably taken in one of those railway-station picture booths. The poses we are confronted with are all the more difficult to cope with in that they obviously depict the way a man *wants* to pose (no arty photography, merely a quick picture). The blandness of these two images, one smiling, one not, must be seen in relation to the previous images, and then, whether or not it is flattering to Sidney Janis, one can realize and accept the truthfulness of the total reality as opposed to the usual expressionistic and obvious fakery of most portraits. The colours are varying shades of green, from yellow-green to bottle-green, except for the stark black-and-white faces on the far right of each row. One automatically reworks the order, either from darkest to lightest or the other way round, depending on one's psychological/visual preferences. The immediate reshaping of the individual segments of representational reality (with Janis as the subject), the initial attempt to make chronological *order* out of chaos, is paralleled by one's response to the colour order, on a purely abstract basis. The whole is much more than the sum of the parts. This isn't a 'statement' by the artist. It is one's immediate impression.

With the *Jackie* there is also a time-fragmentation. Some of the shots are from the time before Jack Kennedy was shot, some after. Warhol wanted to show the passage of feeling from one point in life to another, admittedly during a traumatic situation. This work serves to break any illusion of his half-heartedness in attitude. In the *Jackie*, Warhol is concerned with more than forcing the viewer to make up his own truth from the images, with more than the integration of separate elements into a totality based on a time conception we are not used to. Warhol here is concerned with the minute differential of details. The change in precisely the same image-print is here made more complex in that (for example) in the first horizontal row one cannot tell the difference between the two images except for the exclusion of the accompanying soldier. Is Jackie in the same momentary position or not? This is then resolved as we realize that there is a slight time difference.

43

Jackie (detail) 1965, silkscreen on paper, each image 15¾ × 14¾ in.
Private collection, London

Jackie (detail) 1965, silkscreen on paper, each image 15¾ × 14¾ in.
Private collection, London

Jackie (detail) 1965, silkscreen on paper, each image 15¾ × 14¾ in.
Private collection, London

Jackie (detail) 1965, silkscreen on paper, each image 15¾ × 14¾ in.
Private collection, London

Jackie (detail) 1965, silkscreen on paper, each image 15¾ × 14¾ in.
Private collection, London

Jackie (detail) 1965, silkscreen on paper, each image 15¾ × 14¾ in.
Private collection, London

Jackie (detail) 1965, silkscreen on paper, each image 15¾ × 14¾ in.
Private collection, London

Jackie (detail) 1965, silkscreen on paper, each image 15¾ × 14¾ in.
Private collection, London

That so similar an image can *increase* the emotional potential of our response is one of the strengths of the selection of image and spatial image placement. The visual dialectic serves in no way to retard our emotional involvement, which increases, though, by the small movement, not the melodramatic (and more easily forgettable), more obvious, more shallow movement. Space surrounds one of the two top-row images of Jackie's face. It could move, could have moved, could move in the future, a turn of the head, a progression in time, an openness, a possibility for a movement, a freedom . . . opposed by the Jackie (second horizontal row, right image) underneath the top right; surrounded by blackness, filled-in space, a frontal position hemmed in on all four sides by pure black, an inertness forced by the actual paint on the image, as well as by the emotional equivalent portrayed illusionistically in the original photograph. The live deathmask, with the blackness as automatic metaphor and at the same time a physically real deterrent to free movement of the head; thus the stillness, the frozen eternity, a *thereness* (in this one image only), unmovable. The total screenprint is made up of eight images, which in turn are made up of two blocks of four, which in turn have each a pair of almost identical heads (in the bottom block, the juxtaposition is diagonal). The dialogue is between feelings, with juxtapositions of light and black-darkness, and a linear break in time (from funeral-sadness-face-to-smile-to-deathmask-to-snapshot-image-to . . .). Basic to all this complex conceptualized realization is the Warhol concern with humanizing the technique, through which one realizes, sees, feels, that the rubbing of colour through a silken screen has led to each image's being of a different hue (subtle shades of blackness) and thus the hand-touch of Rembrandt and Twombly and Johns has arrived at an incredibly unobvious but impactful state, a hand-touch whose main strength lies precisely in its dialectic with technocratic means of production.

Jackie 1965, silkscreen on paper, 96 × 60 in.
Private collection, London

Much of what has been elucidated is one way of viewing work which is obviously not didactic in its intent. Nevertheless, one cannot escape with Warhol an intellectual concern which each picture motivates. Apart from the basic attitudes described so far, his work has a built-in system which neither denies emotionality nor degrades thoughts by abstracting them to the point of pure rationalization. Good examples of the intellectual side of Warhol's work are the late soup cans and *Checklist*. First the soup cans: The initial alienation of the viewer through the banality of the soup can image is contradicted and then reiterated by the production in 1968 of a series of new soup can silkscreens based on Campbell's new products (Noodle-O's, etc., with fancier labels). The immediate response is, now, 'That's not a real Warhol!' The paradox is that the art of the past has become so much a part of the life of the present that an old Campbell soup can has become 'a Warhol' while the new one has become 'a fake'. An added paradox is that Warhol's recent paintings and silkscreens have been done by assistant and friend Brigid Polk, who, as well as she comes off in the films, has a mediocrity of sensibility (sometimes) when it come to 'doing Warhols'. Imitation Warhols, funnily enough, are worth while in so far as they expose the sensitivity that Warhol possesses; the outcome is that we realize that it just isn't true that 'anyone can do what I do'. In that sense, Warhol fits into the traditional category of fine artist, higher sensibility, and all. (The same thing is happening with his films, where assistant and friend Paul Morrissey is making 'Andy Warhol films' like *Flesh* and *Trash* which only to superficial observation appear to be made by Warhol. They incorporate elements of his film-aesthetic and technique, but the differences are enormous and plain to see, mainly in compromises with conventional film traditions.)

Campbell's Hot Dog Bean 1969, silkscreen on cardboard, 35 × 22¾ in.
Collection Dickerson and Hill, London

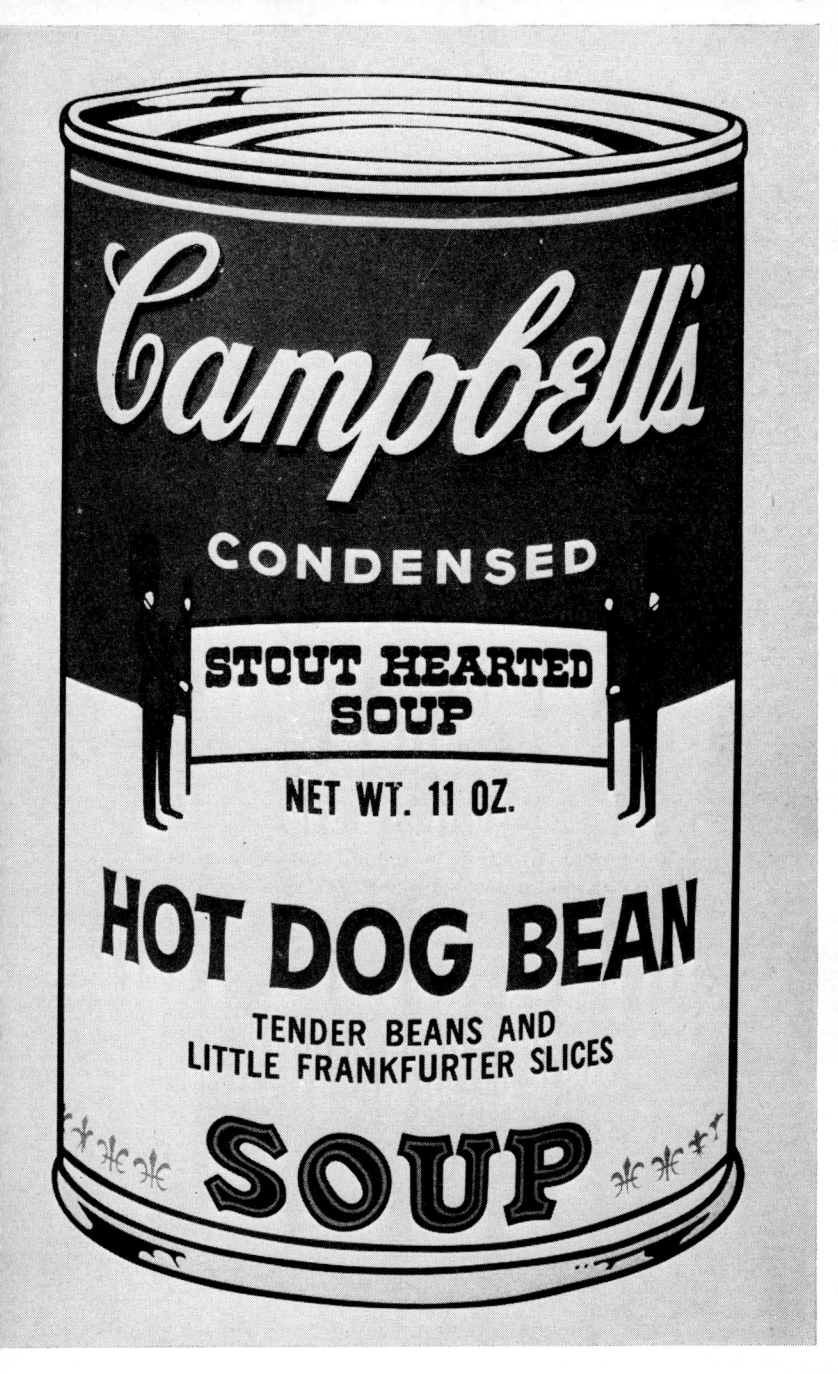

As to works by Warhol which involve intellectual considerations in a less shallow way than the remade soup cans (and the initial ones, for that matter), we can point to *Checklist* (1967). The intellectual aspect of the work is really that part which instigates responses based largely *not* on qualities within the work but rather within the mind and within the personal reactive sense of the viewer based on knowledge, not aesthetic judgements, emotional propinquity, etc. *Checklist* is a silkscreen edition of 150 of a receipt from the local liquor store for a vodka and (something illegible). It is red and black on yellow cardboard. It's a completely open situation which develops meaning only when the individual viewer explores the mystery through private meanings and thoughts related to the *act* of buying drink ; a Warhol-friend (lover?) buying drink, a signature by Warhol stamped on the bottom, a painting of an enlarged slip made out to Paul for consumption of alcohol. One's own past figures largely here. What was the drink for ? (for the print to be made ?) did they drink together and then fuck ? was there a party for many people ? was Paul lonely and thereby motivated to buy a bottle of vodka and drink alone (with the idea later taken by Andy, then enlarged and signed) ? or perhaps 'Paul' was the boy working in the shop who signed the receipt; who bought the drink then, Andy ? . . . All these personal mysteries emphasize personal idiosyncratic fantasies based on an act of mundane banality, putting the work in proper perspective in relation to Warhol's art considerations and the rest of his *œuvre.* The hidden meanings, ideas, and feelings evoked by simple acts (or simple things) bring back the ritualized aspect of modern life, the structures from which our backlog of modern experience emanates. Each item denotes, by its very existence, a set of rituals. Each object becomes a totem. (An air-ticket to Stockholm ; a ticket to the Lincoln Center Film Festival ; both fit into such categories.)

Checklist 1967, silkscreen on cardboard, 37 × 27 in.
Private collection, London

REgency 4-3629 (Prompt Delivery) L-566

Regency Wine & Liquor
1363 YORK AVENUE - (72nd & 73rd Sts.)

NEW YORK 21, N. Y. .. 196...

NAME ...

ADDRESS ..

Similar intellectual-response concerns are connected to any of the simple, single-image portrayals of Jackie. Our response is based, primarily, on how we feel about her each specific day and how we feel about her is the product of a cumulative interaction between our inner make-up and the mass media influence. The change from day to day is initiated by new stories about her, new items which change our response but not the picture. Increasingly as Jackie becomes felt, through the media again, as the bitch of the 1960s, rather than the widow of a 'great' president (who first committed US troops to Vietnam and personally fostered the Green Beret shock troops), we change our overt and internal responses. Eventually we realize how much of the response is linked to what we *think* of her and about her. In the *Silver Jackie* this is emphasized because the image changes from positive to negative depending on the light (silver on white is the equivalent of a negative image-plate). We see a constant flicker from positive to negative, a change of visage, *literally*. This possibility is thus incorporated into one of the many different Jackies. The flat silver bar underlining the image creates awareness of the flat-surface space. This use of a colour (silver) in a colour-chart manner (objective, clinical) also signifies colour as an entity separate from the image itself. The denotations here are about image-making, the *process*, the *material*, and so forth. Thus the repetition of a 'same' image in different ways leads to an incredible widening of our spectrum of available reactions to an art object. In this case, it broadens the intellectual baggage of the art product.

The studies of Marilyn, Liz, Jackie, Elvis, etc., are covered in garish colours, over the sensual sexual image. Marilyn's human essence comes through in spite of the, at first, glaring colours, cold, synthetic, and unreal. A conflict thus takes place between one's reaction to the person underneath and the stencilled cut-out covering (metaphor). The cut-out stencils over eyes, nose, mouth, and hair are a media intrusion forcing feelings of redundancy, of technologically produced unlimitedness. A clown paints simple colour shapes around his eyes, nose, mouth. When a clown smiles, for some unfathomable reason there is pathetic sadness in his expression. Is this caused by the ambiguous situation : where does artifice end and the real begin ? Is it the harsh contradiction of cold colours on warm skin ? Is it that the accentuation of human characteristics is ugly, and in conjunction with a clown's exaggerated gestures, horrific ? Apart from everything else, with her

Silver Jackie 1966, silkscreen on cardboard, 26 × 22 in.
Private collection, London

hair unnaturally fitted like a wig Marilyn looks like a transvestite. The proximity of woman to man and man to woman points to our essential bisexuality. In the specific painting, it gives the person portrayed a greater depth and psychic truthfulness. Her lips themselves raise important questions. When is a smile not a smile; when is a grimace not a grimace? The distance is between anger and pain, toughness and softness; how close is that distance? The edges of the teeth touch. Is it coy Marilyn in sexual stimulation, or aggressive, tight woman; or is it both? We look. We choose. Feelings and thoughts are not opposites.

Marilyn Monroe's Lips 1962, acrylic and silkscreen enamel on canvas; left panel: 82½ × 82 in.; right panel: 82½ × 79½ in. Collection Joseph H. Hirshhorn, New York

Marilyn 1968, silkscreen on cardboard, 36 × 36 in.
Collection Hubert Peeters, Bruges

Liz 1964, offset lithograph, 23 × 23 in.
Collection Hubert Peeters, Bruges

Mona Lisa 1963, silkscreen on canvas, 43¾ × 29⅛ in.
Metropolitan Museum of Art, New York

'Mona Lisa, Mona Lisa, men have named you . . . or are you just a cold and
lonely, lovely work of art?'
(Copyright © 1949 by Famous Music Corporation)

Jackie 1964, acrylic and liquitex on canvas, 40¼ × 40¼ in.
Collection Karl Ströher, Hessisches Landesmuseum, Darmstadt

◀ *Marilyn Monroe* 1962, acrylic and silkscreen enamel on canvas, 81 × 66⅔ in.
Leo Castelli Gallery, New York

Warhol's involvement with popular 'stars' and their immediate transformation into icons of contemporary life, brought about various new formal attitudes. Not being satisfied, ever, with using an image in one way, Warhol continued to experiment. Utilizing Elvis not only for his potential as a face image, then a multiple-face image, Warhol worked out full-figure paintings which incorporated his style and technique, but added to that two important elements: scale and overlapping images. The *Elvis*

paintings of 1964 (triple and double) were over-lifesize. Warhol utilized a concept that seemed befitting only for new realists or abstract expressionists, and gave it to 'pop'. Creating multiple overlapping images was a new use of the serial idea, but more than that it forced a new awareness of time in painting. Because of the sense of conventional film time which we are accustomed to, owing to the unavoidable experience of movies, one relives the action in one's head. One relives the feeling of pulling the gun from the holster, since that is an almost archetypal action for every American (British? French? Russian?) youngster involved in film and television life. And this unconscious reliving of Elvis's portrayed experience, of 'reaching for the gun' and firing, is made all the more filmic in that one can't decipher readily whether the three images are the same or whether they are split-second variations, based on chronological narrative time. Precisely be-because of the confusion brought about by the printing technique, which makes the exact same stencil look different, we associate automatically (again because of the way we've been conditioned through media images of reality) with a progressive forward movement in time. Brought to bear on this is the question of singular experience. The investigation of experience transmitted through the mass media arises, unobtrusively but immediately : how idiosyncratic is any experience? The sameness of experience is countered by the difference in response. (Genocide in Vietnam, Cambodia, Biafra, and the black communities in the United States is either radically rejected ; or accepted by a 'silent majority'.)

One point about the 'double' images of Warhol : often they were made with empty canvas space left of a size to accompany partially or wholly the repeated image. The lack of imprint (the negation of imprint by not printing what automatically would seem to follow) points to an abrupt dislocation of continuity, thus making less possible distancing through repetition. The blockage which an empty space gives to the continuity of images (and this is even stronger in those which are repeated ten, twenty, thirty times, only to be 'ended' by a white space) is a psychically and physically real one. The missing imprint imparts a space which defines the canvas in no uncertain terms, and destroys traditional notions of framing, centrality of image, symmetry, and illusion. A similarity to film consciousness can be pointed out : one tends, automatically, to produce an after-image, (the retinal lingering of an image seen a split second previously). It is similar to Jasper

Elvis 1964, silkscreen on canvas, 81½ × 58¼ in.
Collection Peter Ludwig, Wallraf-Richartz Museum, Cologne

Elvis 1964, acrylic and silkscreen enamel on canvas, 82 × 60 in.
Leo Castelli Gallery, New York

Self-portrait 1966, offset lithograph on silver foil, 23 × 23 in.
Private collection, London

Johns' double-flag painting wherein the top flag is orange and green, the bottom one grey. The instructions are to stare one minute at the top one, close one's eyes, then open them, focusing on the bottom (grey) one. The creation of after-image also occurs when one stares at the sun or a flashing light, then looks elsewhere only to see (internally and externally) the same thing. If that's a car crash, the point is clear. Warhol's experimentation along these lines brings focus to his sensitivity to the possibilities of using the *given* (extra canvas, 'redundant' printings of an already made screen, etc.).

Warhol has created a series of self-portraits in serial form (and multiple colourings), through usage of a single photo-image (in this case an offset lithograph, black on silver, was also made from photographer Burkhardt's picture). To indicate the way Warhol treats reality, the reproduction in this book of the lithograph (which in turn was made from the photo-negative) is imperfect. There is no question but that it is a *photograph of* Andy Warhol. The broken glass points to the fact that it is a picture, framed, hanging on a wall. The reflections in the glass also point to a reality of the object, but a reality established after initial response to the glare in the photograph as real, as if the glare were a reflection of light for each individual reader. Thus before the reality principle is established, confusion sets in. One sees the dents in the paper (on which the original Warhol is printed : silver foil). The dents point to the material, while a perfect reproduction would have negated the existence of this material, thus making vague a very specific situation. Initial confusion overcome, we can relate to what we see for what it really is. Any emotive force and psychological response is now based on what is, rather than on mere shorthand illusionism for the sake of simplicity. This example should clarify to some extent the reality principles which Warhol is concerned with and which, if taken over into other spheres, change completely one's mode of visual perception and relation. A redefinition of reality is called for, and as Warhol goes into film, this principle is delved into with even more force. A strong influence on Warhol's involvement with painting and film is Marcel Duchamp, who, just as Warhol designates as self-portrait a fine-art photograph by a professional, designated non-art objects as 'art'. (When Duchamp died, Warhol was in the process of making a film about him.) Alter the context and you alter the piece. Form is content. And each self-portrait is different, has to be different, in spite of the samenesses.

The self-portraits also point up Warhol's interest in nostalgia which makes objects of the present immediately into objects of the past. Time, and, connected to time, human interaction and *usage,* is obvious. The old Campbell soup can cartons sitting in a corner of someone's flat exude an atmosphere of 'times past' similar to that of a target by Johns (never aimed at, never touched, though touched in its creation), or a moving figure drawing by Giacometti, scantily sketched, hardly present. Of course nostalgia can be a reactionary wish for the status quo of long ago, it can

Campbell Soup Can Cartons 1964, silkscreen on wood, each 10 × 19 × 9½ in.
Private collection, London

also act as a humanizing force, a wish for something from a past that never was. (A search for the past may be less reactionary than a plunge into the so-called future through the progress of ABM missile systems and instant CS gas on every campus.) That is why 'revolutionaries' have as their heroes old men and dead men. Revolutionaries, without quotes, believe not in idols but in themselves, their friends, their brothers. Warhol's option on nostalgia is different from either of these : by creating a past out of the immediate present he relegates to museums of feeling the everyday supermarket kitsch of today. He automatically moves time forward ('progress') while his objects acquire new meaning in terms of their nostalgic qualities and potential, their having been relegated to an 'instant past'. In a sense, a real Campbell soup can is much more unbearably stupid-looking after confrontation with a Warhol, yet both the Warhol product and the 'real' product share a certain isolated minimalness. If nothing else, we are taught to look and interpret intensely. That is, the search becomes, whatever one's viewpoint as to Warhol's intention and position, a search for more relevant responses to everyday surrounding objects. We can find ourselves more acutely delineated by these objects. The consequences of insight are left open.

The Campbell soup can cartons (1964) were important for similar reasons : for the solid, abstract, existence of a block of 'content-less' images which one was unavoidably confronted with. But with these cartons the minimal art aesthetic became of overriding interest : the clean rectangle, the simple line, the audacity to call such a simple form *sculpture* (apart from the more baroque Campbell label stencilled on, which had its usual, consumer-banality implications). The cartons were set up sometimes haphazardly, with emphasis on the infinite possibilities of arrangement, on arbitrariness. This pointed to a degrading of the 'fine-art' sensibility in terms of form and content; at the same time the emphasis on chance differences widened the spectrum of what was permissible in art. The realm of pure, unliterary experience became paramount; a carton placed directly over another gave rise to a set of responses different from those stimulated by a carton placed on another's edge, nearly breaking the balance. Each, though, was equally valid sculpture in terms of minimal sensibility. If one imagines *any* particular possibility, and permutations up to 100 boxes, but without the soup can labels stencilled on, it may be easier to see the sculptural validity

Brillo, Cornflakes, Mott's Apple-Juice Boxes 1964, acrylic and liquitex
silkscreened on wood, various sizes
Collection Karl Ströher, Hessisches Landesmuseum, Darmstadt

of the work. (There are broad connections with David Smith, Carl Andre, John Blake, Robert Morris, etc., though of course each one is concerned with entirely individual and specifically very different sculptural concerns.) At times Warhol arranged the soup can cartons in ordered rows, thus giving even greater abstract relevance to the work. He constantly manipulated the serial (by using one object multiplied hundreds of times, yet with each carton individually fabricated). Here pure, 'empty' space is as potent as 'filled' space, an area taken up by material. The sculptural creation of space is a dimensional, measured, and highly forceful concern. The tension that space created in the confrontation with the self, with the viewer, became important. Warhol, by re-using his initial Campbell soup can image in a totally different way, pushed his art one relevant step further, taking its implications as far as they could go.

Campbell Soup Boxes 1963, silkscreen on wood, each 10 × 19 × 9½ in. Dispersed

John Joseph H.—Jr from *13 Most Wanted Men* 1963, acrylic and liquitex on canvas, 48 × 40 in.
Collection Karl Ströher, Hessisches Landesmuseum, Darmstadt

Warhol's *13 Most Wanted Men* (1963) takes his concept of portraiture to its logical conclusion (although the series does not fit chronologically at the end of his portrait-making period). In this series no colours are used and people are blandly presented as they are. One reacts in a schizoid manner: not knowing why, for example, *John Joseph H.—Jr* should be so sensitive-looking, not knowing why one feels a different feeling now from when as a child one saw the 'wanted men' posted in every post office in every city. Relegation of the image to the definition 'art' and the use of canvas rather than flat-surface cardboard, forces a total change of reaction. The Renaissance framing which Warhol has worked with for his faces previously is slightly looser here: there is more room on all four sides of each person's head, it is a less claustrophobic image, while the subject-matter in the FBI's *13 Most Wanted Men* is much more difficult to come to terms with.

So much of Warhol's work was done between 1962 and 1964 that it is impossible to infer chronological progression (from colour to black-and-white paintings; from tightly framed images to looser ones; from narrative movement in linear time to timeless stillness; from a minimal sensibility to one more nostalgically baroque—*Flowers*—etc., or vice versa). It does not really matter, precisely because it is indecipherable. The build-up of Warhol's separate paintings, internally, parallels the build-up of his way of painting. That is to say, definite cause-and-effect relationships are blurred; specific goals are vague; and consistency is existent only in as much as Warhol takes every image formation to its ultimate conclusion. But there is no consistency in terms of progress, no leaving one field of endeavour or one subject completely, to 'move on'. One can move on by approaching Marilyn differently, five years later. But it takes audacity, because one is wide open to the charge of over-using one's subject matter, of repeating oneself. Only, unlike Chagall, Picasso, Rauschenberg, Hamilton, Stella, most of the Cubists, Impressionists, Expressionists, Warhol never gets negatively boring. And that must be the greatest paradox of all.

6 of *13 Most Wanted Men* 1963, acrylic and liquitex on canvas, each 48 by 40 in.: *left to right* John M., profile; Frank B., profile; John G., profile; Ellis B., full face; Redmond C., full face; Joseph F., profile
Collections Leo Castelli, New York; Castelli; Mr and Mrs Michael Sonnabend, Paris; Castelli; Sonnabend; Sonnabend

The Kiss 1963, silkscreen ink on paper, 30 × 40 in.
Institute of Contemporary Arts, Boston

Sleep 1965, silkscreen on plexiglass, 65 × 36 in.
Private collection, New York

Films

There is evident continuity between Warhol's early films and his silkscreen work. During 1963 he got a camera and shot some footage in Hollywood, *Tarzan and Jane Regained, Sort of. . .* During 1963 he also shot *Kiss*. This film was made of 100-foot reels (about 2¾ minutes each), as shot with empty leader at beginning and end, and fogging, which is a technical intrusion caused by the undeveloped film being opened at the labs. Each 100-foot segment, although shot at twenty-four frames per second, is projected at sixteen frames per second; this was a device frequently used by Warhol in his early films. The first version of *Kiss* was fifty minutes long. The stars were Naomi Levine and Ed Sanders (lead singer of the Fugs pop group, and editor of the one-time *Fuck You: A Magazine of the Arts*); Naomi Levine and Rufus Collins (the high-pitched hyper-emotional and beautiful black from the one-time Living Theatre); Naomi Levine and Gerard Malanga (Warhol's assistant on the silkscreening, close friend, and poet) . . . The Naomi Levine kisses were called, originally, *Andy Warhol Serial.* But naturally, film being a different medium from painting, certain transformations take place. A very important one is Warhol's manipulation of time from twenty-four frames per second to sixteen frames per second. With one flick of the switch, the sense of time is changed. An action, although 'real' in that a real kiss is portrayed, becomes an event even more minutely watchable, clinically observable, with the slowing down of time. Warhol's preoccupation with minutiae, with the nuances of feeling and the *moments* of viewable reality, is established clearly through this technique. One connection to his silkscreen work is the chosen image: Rufus kissing Naomi was later to be used as a silkscreen in its own right (the double film frame was silkscreened on to acetate) and made to serve a different purpose. This connection between the silkscreening and the filming presented itself also by Warhol's use of an image from *Sleep* for an acetate print, and the rape-image from * * * * (*Four Stars*), which was never actually printed but exists as a screen. The abstract figuration of the close-up of two people kissing suited Warhol's exploration of the oneness of abstract reality and concrete reality. Thus the response to the kiss on the viewer's part is based not only on that which is represented but

Tarzan and Jane Regained, Sort of . . . 1963 (Naomi Levine)

Naomi and Rufus Kiss 1963 (Naomi Levine, Rufus Collins)

Sleep 1966, filmstrip screened on acetate, 22 × 12 in.
Private collection, New York

also on the abstract, evocative, light-and-shade figuration, the
strength of the image depending largely on what it actually *is* on
screen (shapes of light and darkness, moving). Warhol's first
films express this (conscious?) concern, and integrate it with an
essential limitation of the medium of film: time. Film is akin to
serial imagery since twenty-four frames per second pick up the
minute changes that the human eye cannot separate in the given

time. A movement looks smooth though in fact it is a harsh directional change from one twenty-fourth of a second to the next. Add to this the fact that there is a time period of equal length during which the screen is literally black (the shutter covering the projector bulb in order to move the filmstrip down one frame), and we are not really *seeing* what we are seeing at all. Conversely to the serial printings, where each painting seems different, in film one cannot really see the frame-to-frame differences because each consecutive image *seems* the same. Warhol said, 'When people go to a show today, they're never involved any more. A movie like *Sleep* gets them involved again.' *Sleep* is a six-hour film of a man sleeping; as it happens, Warhol says, 'I *could've* filmed him for six hours.' As it *is,* the film is made up of three hours of ten-minute segments shot over a six-week period (supposedly). 'It started with someone sleeping and it just got longer and longer and longer. Actually, I *did* shoot all the hours for this movie, but I faked the final film to get a better design.' Each segment is shown twice. Warhol's interest in manipulation takes on its most vivid aspect in such time-sequence changes. Again, there is the follow-through in aesthetic, since, as in the silkscreens *Jackie* and *7 Decades of Janis*, the precise linear time sense is not what is paramount; rather, the important thing is *our* reacting *as if* the time represented were the time we are accustomed to.

The initial reaction by most people merely upon hearing of the 'contents' of *Sleep, Eat, Haircut, Blowjob, Kiss,* and *Empire,* is, 'Oh, that sounds boring.' Rather than counter this viewpoint and try to point out that it is not really boring to look closely, to be aware of small movements, to feel shock at the head or arm movement of a person one is confronted by, one can readily take the other line of argument: yes, that is boredom, but a boredom that must be redefined. So the final question is: what is the nature of boredom, and, by inference, what is the nature of anything. 'I like boring things. When you just sit and look out of a window, that's enjoyable. It takes up time. Yeah. Really, you see people looking out of their windows all the time. I do. If you're not looking out of a window, you're sitting in a shop looking at the street. My films are just a way of *taking up time.*' Warhol's unrelenting cause seems to be the filling up of the vacuum, to fill the empty canvas, to fill the time gaps which existence is made of. What is defined here as 'boring' is the substance of a large segment of life. The filling of the segment of time, in Warhol's case, is

Sleep 1963

Haircut 1963 (Billy Linich)

Eat 1963 (Robert Indiana), filmstrip screened on acetate, 22 × 12 in.
Private collection, New York

achieved through confrontation with another human being. Boredom ('inaction') boringly portrayed is still more involving than excitement ('action') boringly portrayed (as in *Zabriskie Point, Belle de Jour, Weekend,* and *The Damned,* to name but a few). Warhol's early film work can be defined as boring or exciting, depending on one's attitude, and then, in turn, the 'boredom' can be defined as positive or negative. Rather than overemphasize human feeling, reason, meaning, etc., Warhol takes one to the beginnings of confrontation with the 'other'. The easy vicarious identification in melodrama is simplistic and leaves no time for thought, commitment, or revelation. It is, in practical, human terms, worthless. Crying at the sad parts of movies allows one to vicariously identify with the solidly identifiable 'good' against the obvious (usually black-shirted) 'evil'. This manipulation is both easy and pleasing to the general self-esteem. The anger that Warhol's films provoke is an obvious statement about people's fear of (and defences against) confrontation with one another, let alone with one another's *essence.* The physical confrontation becomes so difficult, one can only imagine the sense of impotence at being thrust into a psychic confrontation. It is no coincidence that Warhol's films are the most talked-about and the least seen. Warhol's own awareness of the nature of his work process and

Eat 1963 (Robert Indiana)

its concerns comes through clearly when he says, 'I like com-
mercials cutting in on television every few minutes because it
really makes everything more entertaining. I can't figure out what's
happening in those shows anyway. They're so abstract. I can't
understand how ordinary people like them. They don't have many
plots. They don't do anything. It's just a lot of pictures, cowboys,

Blowjob 1963–4

cops, cigarettes, kids, war, all cutting in and out of each other without stopping . . .' Then he adds, precisely and cynically aware of the lack of intelligent response to his work, '. . . like the pictures we make'.

Using *Kiss* or *Sleep* as an example of his first period of film work, one can analyse to some extent his conception of time; it

was to describe this that Parker Tyler (usually lacking in insight) in an inspired moment coined 'drug-time'. The stoned concentration on the supposedly negligible is precisely a re-creation of the feeling of being smashed out of one's mind; one's head lets go, there's a certain amount of ego-dissolution, and one can float. While in such a state, one can also allow oneself to concentrate, easily, deeper and deeper, without intellectual hang-ups or rationalistic pressure, on the given image: the other person, on screen. Concentration on nuances of movement (in time) not only makes the slightest change of position (even breathing) important but also is involved with silence in *visual terms*. It is not stasis, but a silence *filled*. Silence *per se* is, of course, nonexistent.

The importance of these films lies in their catering to sensibilities which can creatively work with a new premise. That is not to say that the films don't act didactically; they do, in the exposition of film reality as separate from any other reality.

A film such as *Empire's* (eight-hour) emphasis is on the nature of film reality, the gradation of shades from black to white on film, the nature of time's (forward) movement past a nonentity (which the Empire State Building certainly is; so 'nothing' that it attains neutrality), and the emotive connotations thereof through the description of nothingness (a traditional art concern, by now). When one alters one's critical apparatus sufficiently, one can begin to look at film life in a totally different way, and that openness to change affects one's (viewing of) art and life. Warhol's 'time' is in fact relatively short: eternity is felt in three minutes in a Warhol film. Viewing the 'same' image for eight hours heightens (through use of such an extreme) the capacity to view the three minutes. Also, the physical and retinal reaction to eight hours is so different from the reaction to three minutes that in that difference one learns, hypnotically, about change (one's own and that of an 'other'). One can take the idea aspects of the early Warhol films a step further; even reading about an eight-hour film alters one's capacity to respond to the three-minute one, let alone to one of eight hours' duration. Such facts have tremendous implications in terms of one's deconditioning, awakening one from bad (film) habits, one's useless, demented, 'sane' reactions to what is different.

Empire 1964

Batman/Dracula 1964, never completed (Jack Smith, Baby Jane Holzer, Beverly Grant, Ivy Nicholson)

Opposite
Couch 1964 (Gerard Malanga, Kate Heliczer, Rufus Collins)

Couch 1964 (Gerard Malanga, Piero Heliczer)

The early films integrate the subjective and the clinical. As it happens, the clinical non-moving camera (films from his earliest period were totally static in that sense) does not record in any objective way, precisely because one's confrontations are never objective. Warhol's early films more than any bring us to realize that aspect of reality, both on an emotional and intellectual level. You dig something or you don't. Grooving on someone lasts as long as you let it. 'My first films using the stationary objects were

Mario Banana 1964 (Mario Montez)

also made to help the audiences get more acquainted with themselves. Usually, when you go to the movies, you sit in a fantasy world, but when you see something that disturbs you, you get involved with the people next to you. Movies are doing a little more than you can do with plays and concerts where you just

13 Most Beautiful Women 1964–5

have to sit there and I think television will do more than the movies. You could do more things watching my movies than with other kinds of movies; you could eat and drink and smoke and cough and look away and then look back and they'd still be there. It's not the ideal movie, it's just my kind of movie.'

13 Most Beautiful Women 1964–5

13 Most Beautiful Boys 1964–5 (Gerard Malanga)

50 Fantastics and 50 Personalities 1964–6 (Allen Ginsberg)

50 Fantastics and 50 Personalities 1964–6 (Donovan)

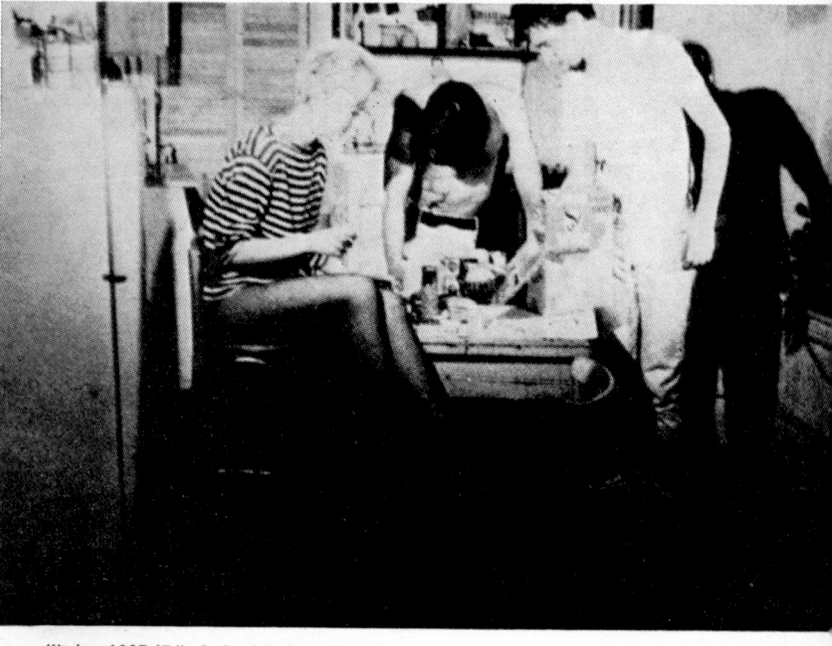

Kitchen 1965 (Edie Sedgwick, Rene Ricard)

The first period of Warhol's film-making had been devoted to still-camera recording of simple 'actions', without use of sound, scenario, or scene (other than a bed, a wall, a couch). The second period of Warhol's film work, of which *Kitchen* (1965, seventy minutes) and *Harlot* (1964, seventy minutes) are the most notable examples, utilized sound, as well as scenarios by Ronald Tavel. *Harlot* was the underground's (and Warhol's) first film to use optical synchronized sound directly on film (while shooting). Scripts were written, often following original ideas by Warhol. But it isn't as simple as that; somehow the indeterminable presence of Warhol, his decisions and speculative ideas about what each film should be, moulded the films in his image. Says Ingrid (Superstar!) 'I'm so mad at Andy. He just *puts* you out there and makes you do everything.' Says Viva, 'I have Andy now to think ahead and make the decisions. I just do what he tells me to do.' And what does Andy say? 'I don't know where the artificial

stops and the real begins . . . With film you just turn on the camera and photograph something. I leave the camera running until it runs out of film because that way I can catch people being themselves. It's better to *act* naturally than to set up a scene and act like someone else. You get a better picture of people *being* themselves instead of trying to *act*.' Although judging from Warhol's films, *acting* is part of *being* oneself. The second period, although encompassing scenario and sound, still held rigidly to the camera's singular viewpoint, and there was no editing at all. Warhol's *Kitchen* introduced the concept of the superstar, an obvious allusion to the Hollywood presence and star-quality which made, for example, Marilyn Monroe, Jean Harlow, Hedy Lamarr incredibly attractive to audiences because of their projection of an *inner* self rather than any specific characterization ; the real personality (including camera-conscious self-presentation) projected itself through the mask of character role. Role confusion set in. The conventional stars' sexual blurring also becomes obvious. In Mario Montez's case (as Jean Harlow in *Harlot*) the female impersonator exaggerates so-called female qualities, expressing character as cliché. The camp attitude here is the self-conscious defence against the charge of over-acting or being over-serious. Also important as a new concern, is the levelling process of man and object, especially clear in *Kitchen*, as they confront one another in the white-walled enclosure. That is *not* to say that Warhol treats people coldly, as sexual objects ; rather, Warhol brings the human being to a oneness with his surroundings, the objects (steam-iron, mixer, refrigerator, etc.) in a room. Background and foreground become equalized as the involvement of the viewer becomes concentrated on the drama of placement in space, of movement in space, of shape touching shape. In that sense, these films betray a painter's sensibility, or rather, what should be a film-maker's sensibility but usually isn't. The reliance on macroscopic rather than microscopic movement betrays a new conception of action for Warhol, and only in the later films such as *Lonesome Cowboys* and *Bikeboy* do we get a fusion of the two : the intense concentration on a segment of reality (a shoulder, a head) for long minutes of film time, as well as the relationship to the frame of *whole* body movements (walking from frame-right to frame-left ; standing up, sitting down). Also an important development is the incorporation of the consumer product, Sealtest Milk, Coca-Cola, Ballentine Beer,

Goodman's Kosher Matzos, etc. Objects take on social signifi-
cance. A theoretical example would be that of the alienated
object, no longer a carefully painted (or, in terms of film, carefully
placed) one. Not hand, shoe, coat, scarf, but rather the labelled
canned fruit juice that happens to be on the kitchen counter, and
that, when accidentally knocked over, 'happens' to make loud
crashing noises overpowering the visual and aural concentration
of the viewer. Gestural super-reality converges with overtones of
dada-absurdity. Emphasis is on *everything* that happens. Emphasis
is on everything that *happens*. One's concentration is forced into
a different focus, and one's reflexes will never be the same.

Kitchen begins to use techniques which *Chelsea Girls* (to be
discussed later) makes more apparent use of. The actors seem,
through intermittent sneezes, to acknowledge one another's
existence. The dialogue, often inaudible, takes on aspects of
freudian parody : 'Isn't mother a boy's best friend ? !', and sexual
irony such as, 'Why does everyone in this movie have the same
name ?' Answer : 'You don't have sex with a name, do you ? !' As
an alienation technique (willed or not), Warhol interjects a
photographer into *Kitchen,* taking us from vicarious involvement,
and directing our awareness to place. This becomes acute as
the photographer on screen moves *in front* of the camera and
momentarily covers the scene, as is common when 'real' people
in an audience move through the aisles and have their shadows
projected on to the screen image. Each act is, as always, a
metaphor. Although on one level it is possible to explain the film
and force awareness of the ideas this way, the effect of watching
a Warhol film is still far greater than merely conceiving it in one's
head. Tavel's last filmscript for Warhol, *The Shopper,* was called
Hedy, or *Hedy the Shoplifter* or *The Fourteen-Year Old Girl.* (The
allusion is to a film star who got caught in one of her kleptomaniac
acts of shoplifting, in a supermarket; neurosis too is a star-
quality. But because he risked being sued, and rather heavily at
that, Warhol had to change the film's title.) According to Gerard
Malanga, 'The film displays further ingenious manipulations of
space (begun in *Vinyl*) through shifting and replacing of props.
'Camp' and 'private' acting are integrated into a wider dramatic
scheme, achieving the utmost realism through the utmost
absurdity.' Tavel, who wrote the scenario, was extremely talented
at verbal explication of the Warhol film-genre of that period. His
Banana Diary in *Film Culture* (the official organ of the New

Harlot 1964 (Mario Montez, Phillip Fagan, Gerard Malanga, Carol Koschinskie)

York Film-Makers' Co-operative, and centrepoint for various film-makers) attests to his acute awareness of the total happening that a Warhol film is. From his transcription of the dialogue forming the background to *Harlot* (a dialogue largely inaudible on the actual film) one gets an excellent idea of the tone of the verbal aspect of the film. 'T: "These gypsy microphones get blamed for everything." F: "Phoney Mike!" T: "Mike? He was one of my former husbands." F: "You and your band of husseys." T: "Husseys? It was all legal, consecrated by the church and everything else." F: "Get that banana." T: "Oh! The harlot, The harlot. Let her put it in the crouch of her knee." F: "The knees. That's why she's called Denise." T: "Let her put it in the garter of her stocking!" F: "Jealous banana trees bending down in hurricanes of rage!" T: "After all, I know more about her than you do. I was married to her!" F: "Old banana peel you used to be real." T: "Here we go round the banana tree—you and me!" F: "I object!" L: "Objection overruled!" T: "Old bananas for new! Oh bananas for you!" ' And so on. The background dialogue/trial-ogue/monologue on its own establishes a mood which directs one's attention: the revelation of the sound is in its obsessively logical absurdity (relating *everything* to bananas). A conscious attempt is made on the part of the three 'readers' (Harry Fainlight, Billy Linich, and Ron Tavel) to *talk at* one another and score points. The social game with its heavily sexualized undertones/overtones reveals aurally the psychic confrontations. There's an almost immediate connection with the visible, since the words at once relate to, and ridicule, the action. The 'story' may be summarized as follows. Harlot, the man-queen star, leans against a lesbian lover. Harlot has a Mafia-type lover behind her, the lesbian has one as 'static' as herself. Sitting on the lesbian's lap is a white cat which is the focus of attention. All action (a near-orgy of banana consumption) stems from this basic figuration.

Before moving on, it should be said that much of Warhol's filmic art consists in his selection. He films with relative openness to the chance happening, but a majority of his films have never been publicly released because he doesn't find the results good enough, and in many cases prints have not even been made from the master. From the earlier periods, only about ten films are shown and close to a hundred have been shot. The right moment can only be culled after the shooting is over, and (in spite of this point's being philosophically arguable), all people don't come out

Screen Test No. 2 1965 (Mario Montez)

Poor Little Rich Girl 1965 (Edie Sedgwick)

equally well, equally interesting, even equally 'boring' in a positive sense. The choices, (which involve subjective taste) are then made; *within* the process of the film-making activity itself, there is a large area of freedom. Any restrictions by Warhol are the shaping aspects of the film, while the people on-camera can be themselves as much as possible, and 'being oneself' includes consciously and unconsciously acting out one's fantasies. The quantitative amount of truthfulness perceived in Warhol's films forms the *quality* of Warhol's art.

The third section of Warhol's development as a film-maker was, roughly speaking, concerned with films with scenario and co-direction by Chuck Wein. Among these, *Poor Little Rich Girl* (1965), *My Hustler* (1965), *Restaurant* (1965), and *Beauty No. 2* (1965) are the most important.

A short description of *Poor Little Rich Girl* will perhaps suffice to give somewhat of a feeling as to what they are 'about'. The

Vinyl 1965 (Gerard Malanga, Edie Sedgwick)

My Hustler 1965 (Paul America)

◀ Set of *My Hustler* 1965 (Paul America)

first reel is out of focus, except for a few seconds. Edie, the star, tells of her inheritance. She has spent it. She moves around the room, between bed and telephone. She shows her beautiful coat. Nothing else 'happens'. In this period Warhol has begun to move the camera, speech is becoming more 'regular', what we are accustomed to hearing, though the layers of satiric and politico-sexual meaning are still strongly in evidence.

The end of the third period and the beginning of the fourth is presented in the form of *Chelsea Girls* (1966). Here we have a distillation of all that is best in Warhol's previous work, as well as hints of the forthcoming techniques and ideas in * * * *, *Lonesome Cowboys,* and *Fuck* (or *Blue Movie* as the magazines call it).

Chelsea Girls is almost three and a half hours long. It is projected on twin screens, thus the total film time is close to seven hours.

Shooting *Chelsea Girls* 1966 (Marie Menken)

The half-hour sections (with unrelated 'content') are spliced together; as the film moves forward in viewing time, connections between segments become formed; like it or not, a certain psychological linearity has taken place, a consciousness of beginning and end as less than arbitrary. There is a sound-track for each reel of film on either projector, and although the sound could be run simultaneously, it isn't. Again, although the order

Set of *Chelsea Girls* 1966 (Brigid Polk)

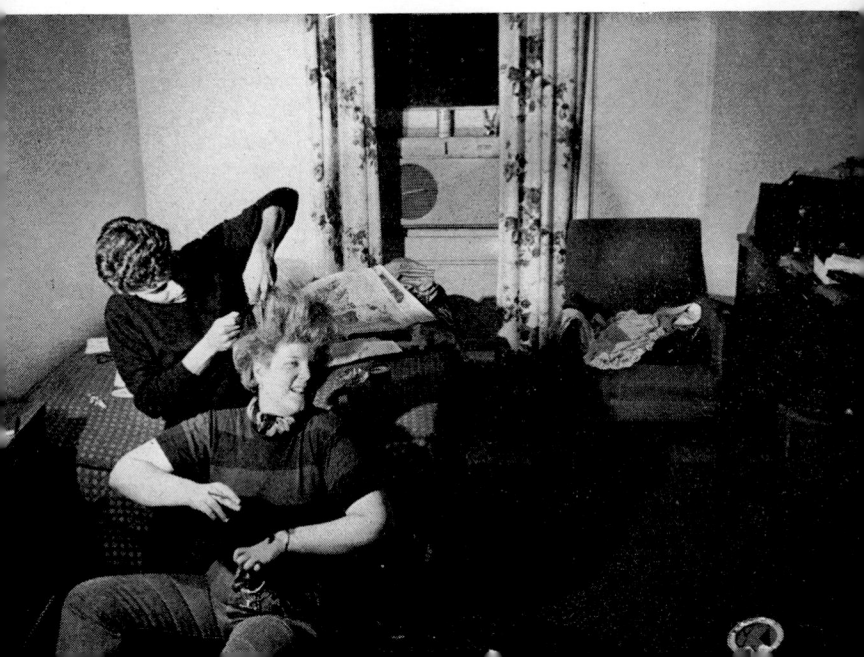

of reels is definite, and the order of sequences within each reel, through splicing together, is established, the two projectors are not synchronized and therefore at each showing the left screen image and the right screen image correspond differently. Colour film is projected on the left, black-and-white on the right. One immediately noticeable difference between the left and the right screen images is that, with the exception of the Mother/Son Oedipal-confrontation section (Malanga/Menken), the colour sequences are sophisticated in terms of sound, the picture 'glossy'. There is also a greater openness of frame space, something which Warhol's future colour films were to explore further. The intensity of feeling would not necessarily be destroyed because of a less claustrophobic frame-space set-up. The concentration here is not so much on the minutiae of slight movements as on total happenings, for example, the shapes of colour and light stroboscopically projected on camera-orientated LSD-tripping (cum striptease) by Eric Emerson. The camera lingers on a beautiful and moving monologue, an ode on (not *to*) impotence, the tragic, no, pathetic impotence of human means towards realization of the mythical wish. Eric speaks of wanting to be a drop of sweat ingested into another human being. An idiosyncratic desire is fantasized into archetypal communicativeness. This expression by the tripper is an immediate, intuitive correspondence to our unfulfilled wish dreams, our beautiful but frustrated attempts to enter into one another, to become one another in an ego-dissolution that is as open and loving as it is rare. In this segment traditional filmic form/content is re-established and this has shown that Warhol, when he wants to, can captivate completely, in the formally conventional cinematic sense. But because this is a segment and not a whole, it does not destroy Warhol's sequence-dialectic in *Chelsea Girls*. We are pulled into this one film segment, only to be released into a totally different orientation later, on the opposite screen: Mario Montez in drag is camping it up, playing for all its worth the sexual extremes of a man acting 'woman' to the hilt. She sings a song, pseudo-provocative gestures and all. The obvious put-on of the Hollywood aesthetic, the fake, farcical superficiality, is part of the message, part of the screen qualities of the star. The tawdry gimmickry of the Hollywood genre is explored and exploited at the same time; the sexual ambiguities of the scene are increased when Ed Hood and two other homosexuals alternately fondle and

Chelsea Girls 1966 (Marie Menken, Gerard Malanga)

cajole one another on a bed. The climax of the scene is the intrusion of Ingrid, sexy, slutty superstar, fingering under Ed Hood's pants with one hand and, at the same time, with a wry look straight at the camera (audience) giving one and all the American 'fuck-you' signal, middle finger pointing up. But rather than offering this signal contemptuously, Ingrid delivers it with a coy sliminess that makes humour out of an essentially serious triple-triangle sex situation. The levels of reality and put-on are virtually indistinguishable; fantasy and reality are one (as opposed to being indistinguishable). A constant flux governs our response to this section of *Chelsea Girls*, especially in relation to previous (and

Chelsea Girls 1966 (Nico)

◀ Set of *Chelsea Girls* 1966

forthcoming) scenes. Warhol achieves a totality through the segmented-fragmentary form, a totality not in terms of an easily verbalized statement but in terms of a complex intertwining of emotional/intellectual presentations to form a whole experience, the experience of *Chelsea Girls*. Two other examples should suffice: the opening sequence and the final one.

In the opening sequence we observe Nico in close-up, trimming the edges of her bangs. The camera watches her, an intimate claustrophobia building up simply through the passing of time. The cumulative effect of time in itself is something explored by Warhol from his first film 'experiments'. We watch Nico; her head movements, her stares, her words become at once emotional *equivalents* to meaning while taking on surface meanings within the context of the film, as specific gestural actions (trimming hair because it is too long, gets in her eyes, etc.). She is speaking to someone out of frame. This is another Warhol preoccupation: the life that is unseen, the life that one must create

in one's head, the life that, because it is out of camera range, usually remains unexamined; the life that exists, for the viewer, only through subjective magic. The smallest impulses are given by Warhol, and the viewer begins his journey, the creating of the 'other' inside his own head (self). An action that is so minimal as to be hardly definable as action is, for example, made up of a few mumbled syllables from the out-of-frame personage to Nico. An occasional zoom-out reveals a child stumbling around in what we now realize to be a kitchen. With water running and objects being touched we are bombarded by sound. As in earlier films here again we see the distillation of a technique used to its ultimate effectiveness: forced to consider the visual because we have been so rudely confronted by the impossibility of deciphering aurally. At the same time, the overbearing noise elicited by small happenings ('backstage' or 'offstage' being non-existent concepts in Warhol's films) has awakened us to the equality between the object-person and the object-thing. A levelling-out gradually takes place; things take on their 'correct' (by now ritualistic) importance, then give way to a person's hand movement, eye blinking, etc. It's a constant see-saw of relative intrusions on the complacent orientation of the viewer's consciousness. When Warhol finds the midnight movie on television as abstract as his films, he is overstating. *His* films are less abstract, since what does happen in a Warhol film, no matter how absurd or outrageous, is ultimately a signal from (about) a person, not a cardboard characterization.

The last segment of *Chelsea Girls* is the (by now notorious) pope sequence. A man known as Ondine is playing pope and running a confessional. The much-used Factory couch is his base; it becomes the passive centre of the film. Around it, off it, the action occurs, after the initial situation is set up. The pope breaks into a rage during verbal repartee with a girl 'penitent' who puts him down. He's been shooting-up Coca-Cola (he has?) and is now vehemently holding on to and shaking the bottle, engaged in a hysterical temper-tantrum which continues as the action moves offscreen, the girl running out, pope screeching after her. He's been insulted by her, becomes totally defensively aggressive, and starts laying in on her (verbally). He shouts at the camera 'turn the fucking thing off', runs out of frame again; dimly lit in the background one sees the figures, the pope is still screeching, and the well-lit couch just sits there, immobile (as couches tend to

Chelsea Girls 1966 (Pope Ondine)

Chelsea Girls 1966 (Pope Ondine)

be). The pope returns and monologues *at* the people behind the camera (Warhol, assistants, friends, etc.) ; he is totally screwed up and angry, while the film, interminably, runs on, and on, and on. The medium has its strongest existence yet because of this constancy, its mechanical unfeeling continuance in the face of human rage. The ineffable *movie* is unrelentless. Reality and play-acting have coalesced, and the meaning of the pope sequence, after the emotional shock and human terror of the situation have been absorbed, is the inseparability of the *felt* action and the *acted* documentary. Reality on one level has become the reality of fantasy on another. For once there is no urge to use an intellectual scalpel to analyse. The *Cahiers du Cinéma* said : 'Warhol abuses the camera ! A failure to produce valid art ! Unfeeling and Inactive !' All *Time* magazine had to say was, 'DIRTY, FILTHY !' The message was 'stay underground !' It didn't.

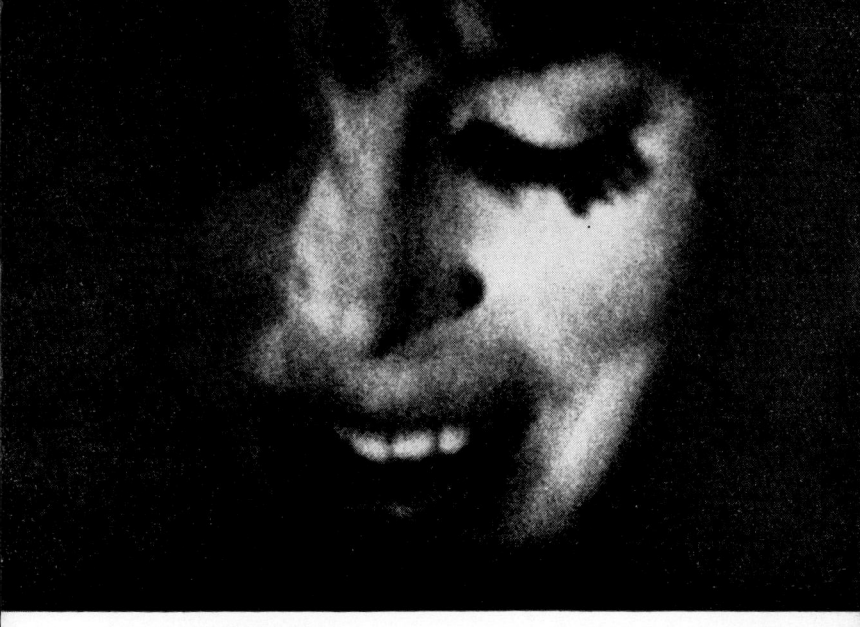

**** 1966–7 (Nico)

The fourth period of Warhol's film work (roughly speaking) includes films such as * * * * (1966, shot in thirty-minute segments to make a film total length twenty-four hours, disassembled after one showing; a two-hour version exists); *I, a Man* (1967, 100 minutes); *Bikeboy* (1967, ninety-six minutes); *Nude Restaurant* (1967, 100 minutes); *Lonesome Cowboys* (1968, 110 minutes); and *Fuck* (1969, ninety minutes). This period involves colour films of commercial length (except * * * *). The films all have excellent sound-tracks if played in the right condition. Direction is usually in the form of an idea by Warhol; action is on the microscopic minute level of the first period as well as on the macroscopic large-movement level of the second and third period films. There are no scenarios. Paul Morrissey's camera work seems sometimes to be apparent, but for moments only. Generally these films were 'directed' and shot by Warhol.

**** 1966–7 (Nico)

**** 1966–7 (International Velvet)

**** 1966–7 (Edie Sedgwick)

**** 1966–7 (International Velvet, Alan Midgette)

I ,a Man 1967 (Tom Baker)

The press-handout for *Lonesome Cowboys* reads as follows:

Romona (Viva) and her nurse (Taylor Mead) are searching what seems to be a ghost town for some companionship, when Mickey and his gang appear at the end of Main Street and encounter them. A preliminary skirmish is resolved by the sheriff's intervention, and the gang chase the couple out of town. Viva pauses to sarcastically inquire into the nature of Mickey's (Lous Waldon) relationship with his brothers, and gets thrashed for her trouble. Taylor Mead pauses to invite Tom Hompertz out to the ranch, and tries to lure him with a little song and dance. In the gang's

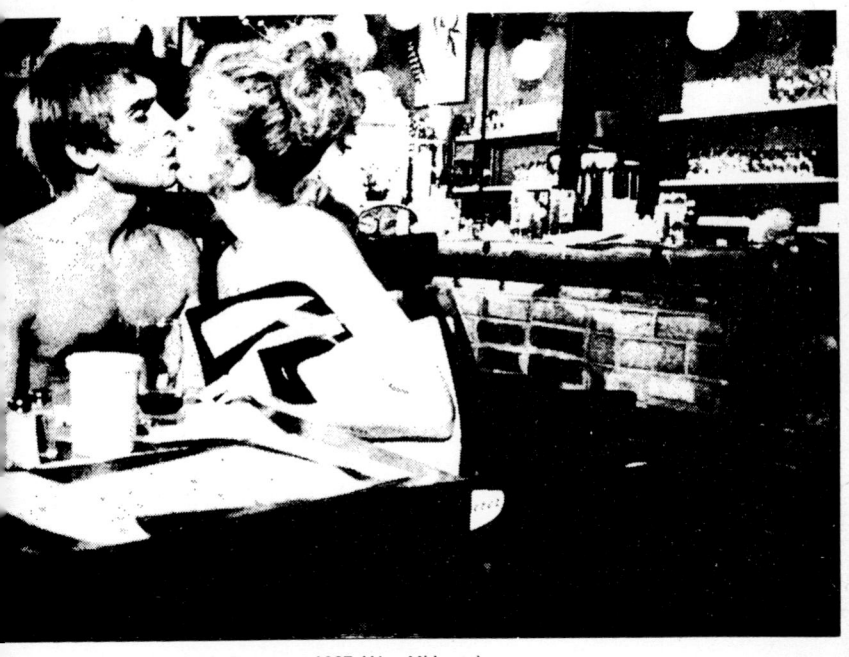

Nude Restaurant 1967 (Alan Midgette)

camp the following morning, Eric Emerson drags Louis Waldon out of bed with Tom, to ask just who Tom is, since they picked him up on the trail just a few days before. Eric's cockiness provokes a wrestling match in which he comes out worst. The gang ride over to Romona's ranch, breach Taylor Mead's feeble defence, and rape Romona. Afterwards the sheriff (Francis Francine) claims to be too preoccupied with cattle rustling to take action. Some of the brothers discuss their actions; Julian Burroughs attributes their degeneracy to lack of parental discipline. The gang settle down to life on the ranch; Viva seduces Tom Hompertz, Taylor Mead falls for Joe D'Allesandro, Francis

Francine does an elaborate drag for an unseen 'customer'. Gradually Eric and Tom separate out from the group and decide to split and surf in California. As they ride off, Louis Waldon is left protesting and uncomprehending.

Lonesome Cowboys has a linear thread of coherent action running throughout, though this does not imply concessions to chronological time or 'logical' space. It merely means that there is an ending which, in retrospect, is the summation of the preceding moments (which last for about 110 minutes, commercial-feature time-span).

The most important aspect of the film is the consistent oneness of reality and fantasy; that is, what is said by the cowboys ('just friends, people . . . in a cowboy situation') is meant at once as a reality within the Western-genre set-up, within the framework of the *story*, as well as within the actual psyches of the actors. When Louis says to Eric, 'You went to ballet school, wanted to become a dancer, now you want to be a cowboy . . .', he means it. Judging by Eric's splits, he did go to dance-lessons (this also connects circuitously to Warhol's 'I never wanted to be a painter. I wanted to be a tap-dancer'). Judging by the way people talk to one another in this film, they are re-enacting relationships and internal states, with reference to the set-up cowboy situations. The influence of 'being filmed' is equally apparent in some of the more extroverted exhibitionistic moments. There is a specific reality forged for each given moment in time. *Lonesome Cowboys* does not compromise with Warhol's purist cinematic concerns, even though it moves full force into more than a single-situation filmed happening. It uses the structure it has set up, the genre-Western, in order to analyse and expose our personal, interpersonal, and communal lives. It cinematically takes on the parallel construction (and restructuring) of the life of our minds and the life of our bodies. It is a symbolic film but the symbols are not cardboard characterizations or puppets for ideas; the physical people embody *themselves* while constituting an America that is at once reflective of, and totally opposed to, the current system, all the way down the line. The attitudes in *Lonesome Cowboys* are explicable in terms of the following categories: Sex, Politics, Camp, the Superstar, and Scripting and Time.

SEX: Sexuality is explicit. The brothers sleep together naked under blankets; when woken up Louis gets up, prick and balls

Lonesome Cowboys 1968

exposed, and pees for some time, then sits around casually with the others, chatting, drinking coffee, etc. The situation is as real as it probably was in 'frontier-days'. The homosexual, or rather, bisexual element is that one aspect that is incredibly latent in the usual cowboy film, as well as in the 'historic' retelling of America's grandiose heritage. Cowboys *must* have fucked each other while they were on the range and away from women, who were usually only encountered in the brothels of the frontier-towns which we never hear about. In *Lonesome Cowboys,* sex is naturally portrayed by showing naked cowboys under blankets together, uncoy, tough, men. At the same time, these men have heterosexual pleasure from raping Viva either physically (as Tom does) or vicariously (through their voyeuristic and excited watching). There's sexual parody involved here in the overacting. These men (and Viva) are impersonating; the parody is that *they* would not rape to get sex, nor do they get sex voyeuristically: they sleep together at night. So Warhol manages at once to show their real selves among men, and their sexually ironic potential (as concerns the straight American Western-genre film, which in turn reflects accurately the American psyche). Sex in *Lonesome Cowboys* is unerotic; the erotic *potential* is shown but the eros of sex is mostly withheld. The matter-of-fact sex of the men around their campfire sleeping together, dressing in front of one another, etc., is the sex without anxiety which our present culture disallows.

Part of the sexual interaction in *Lonesome Cowboys* is in the form of fun; boy-men splashing one another with beer; wrestling among the cacti ('watch out for the cactus!'). The masculine ritual is performed with a naturalness that is unprecedented; it exposes the sick confrontations in the usual Western, where perversely *latent* homosexual wishes are played out to the full, disguised by the acceptable notions of gun-fights, round-ups, brawls. It is the disguising of these values that is sick, not the values themselves. Repression of *anything* is sick if that repression leads to (or betrays) an unfulfilment. The concept of sublimation must imply enjoyable redirection or substitution of actions, without any latent overlay, mental or physical. Warhol's cowboys indulge in the masculine rituals that, if performed in seriousness end in the horrors of our obscenely sick society, but the laughter that accompanies the beer-splashing in *Lonesome Cowboys* is far from *Dual in the Sun, The Gunfight at OK Coral,* or other such manifestations of impotent, fixated cigarette-ad masculinity.

Lonesome Cowboys 1968 (Louis Waldon, Tom Hompertz)

Lonesome Cowboys 1968 (Viva, Tom Hompertz)

Lonesome Cowboys 1968

Lonesome Cowboys 1968 (Viva, Tom Hompertz)

Lonesome Cowboys 1968 (Francis Francine)

The film is not erotic. But it would be a mistake to think that
Warhol is anti-sex. Warhol's film, on the contrary, mediates against
the prevalent ('modern') commercial porno-sex (its overloaded
obviousness and shallow exaggerations). When he has a reason
to he uses sexuality to the hilt; men in drag (Francis Francine);
cunnilingual rape (of Viva); hair and object fetishism (the boys'
preoccupation with the masturbatory ritual of self-touch of hair,
as in the Nico-sequence of *Chelsea Girls*; also an object-fetishism
in connection with (cowboy) gear: an assertion of one's (sexual)
existence, not through the self but through the symbol: holster,
hat, boots, stirrups, etc.).

The pre-drag scene with the sheriff serves to confront Louis Waldon (elder brother) with a foil, an opposite, and in that confrontation, assert his (right to) humanity. When Waldon says to Francine, 'We don't make fun of you when you dress up, wear wigs . . .' he is making use of the sexuality of the 'other' to assert his own rights; sexual freedom is the core of a man's freedom, and its symbol as well. The personal life of the individual is guaranteed when his sexuality is not persecuted, not questioned, not felt as a threat.

The rape of Viva serves to assert the group affiliations of the brothers, in establishing them as a whole, united against the woman and the sheriff, a law unto themselves, an anarchic outlaw horde.

The object-fetishism establishes, in spite of the group, an individuality, an existential self-reliance and need for self-touch in the face of (unconscious) loneliness. The obsessive fingering of one's own hair, the obsessive repeat-action of drawing a gun, holstering it, drawing it, establishes (extends) the body of the individual. The physical self is made to exist through impulses given by the mind; and when the mind is in doubt, it reverts to obsessions, rituals, repetitive actions, all in order to establish an identity for the (sexual) self. *Lonesome Cowboys* thus establishes a group made up of the existential individuals searching for a common sexuality. Warhol has set up a situation in which love of brothers is at once the beautiful love of friends ('. . . they aren't really brothers, they're, well, friends, sleeping together, or whatever, but they say they're brothers so people won't talk') and at the same time an assertion of sexuality devoid of the cliché hypocrisy so common in the 'Western' we are accustomed to and indoctrinated by. Using his cowboy brothers as a microcosm of what *should* be, he at the same time records with his camera what, for the actors, *is*. He thereby radically rejects what we have been led to accept by the commercial Western as both truthful (documentary) and good (moral fiction).

POLITICS: *Lonesome Cowboys* as social microcosm delineates not only a sexual metaphor but a political one as well. The revolution of life-style is here conducted partly in an amoral manner, partly in an immoral one. The political aspects of the film take on a decidedly nihilistic taint, closer to Beckett than Marcuse. At the beginning of the story Viva and Taylor (waiting for . . .)

Lonesome Cowboys 1968 (Joe D'Allesandro)

stroll around the main street, yelping, 'We're looking for a little companionship' (Taylor throwing his feet around as if they were jello, the top half of his body joggling back and forth as if it were made of rubber). Out of nowhere (behind the painted Arizona-scenery; in Arizona!) strange riders appear. After the initial confrontation, Viva screams, 'Your boys turn me off!!! Completely! Not one has hair long enough to warrant a second look!' This interpersonal let-down (or failure to excite) is paralleled by a social negativism later on in the film, ' . . . have a home, get married, settle down, have children, and wait for world war one.' The political awareness of the period (in the late 1890s, the West was full of cowboys) brings home to the viewer the terrible non-related blankness which is inspired by most of the motion picture industry's products. When in a Western has one been aware of a world *outside,* a world of political reality? In *Lonesome Cowboys* we are for the first time in a 'Western' made aware of the relativity of that particular fantasy, its integration into history. The reactionary Western called for complete identification with a non-existent mythical past, incorporating very real archetypes of racism and genocide; our 'heritage'. *Lonesome Cowboys* presents the co-minglings of a group of cowboys in a society (sheriff, symbol of law n' order, etc.) and relates that, however subtly, to the 1969 existing world outside, and to the latter's influence upon each individual's feelings. Ennui and hopelessness. A dejected, bored, unavoidable waiting . . . for world war one.

The brothers want to live their lives in the sheriff's territory; he 'should' run them out, for raping Viva. But he too wants to be left alone. Sartre's 'hell is other people' is here negatively demonstrated: leave the other guy alone and you're basically going to be all right. There's anarchy when someone breaks the rules. So what. One's morality dictates the answer: give him the electric chair, or reply with a shrug. The first possibility has been proven *not* to have any deterrent effect, and leads to the killer-mentality. The second possibility has never been tried. The political consequences are left open by Warhol. But the viewer can bridge the gap with his own decisions. *Lonesome Cowboys* is a film that begs to be interpreted personally.

CAMP: There's implicit social criticism, in spite of the camp overtones: ' . . . families are breaking up early these days . . . children are getting their own horses . . . too soon . . . we need a

Lonesome Cowboys 1968 (Taylor Mead)

big brother, somewhere, who can help us out . . . those of us who are orphans . . . then we'd be happier children.' This deadpan audience-directed head-on speech by Julian Burroughs is the mock-cry of the realization that a big brother does *not* get rid of the loneliness, does not answer the needs, does not fit the boy scout cliché. By answering the problem in this simplistic manner, Julian is throwing light on the melodramatic manipulation of such a speech, and at the same time negating its conventional relevance. One identifies, the sadness is easy to *feel*, an orphan blah blah blah, but at the same time his words fit so well into some speech by some misled leader that we feel we've heard it all before. Any emotional power it might have is countered by the conscious campiness, the self-irony implied. It just sounds too well rehearsed, too *written* to be real (not that the actor reads a script; it just sounds that way). It's very difficult to define 'camp', because so often its precise strength lies in its closeness to deep feelings, to states of awareness less, not more, shallow than most.

Straight humour is much more easy to identify. Taylor going into a monologue about someone, 'Sheriff ! ! ! Sheriff ! ! . . . he's got mascara, he's got a hard-on, and he's smoking hashish !' Straight *camp* is when Eric spends ten minutes explaining how to pull a gun from its holster, when he takes something irrelevant, and obviously so, seriously. It's the childish conditioning towards certain things which gives them a (ridiculous) relevance for some people; this is parodied superbly by straight-faced renderings, and the result is 'camp'. Consciously taking kitsch seriously is also camp; this applies more clearly to some of the paintings, such as *Flowers*. In film this is subtler, as one often has a complex situation rather than a clear, simple image or singular action.

A break from campiness is seen in much of Joe D'Allesandro's 'acting' because as a person, in Warhol's films, he means what he says, with little awareness of the intellectually discernible humorous possibilities. 'I wish I could go to the beach, away from the bunch . . . lots of women and beautiful men . . .' Coming from Viva this would be camp innuendo, on account of the complete control she exercises over what she says; in that sense, camp has to do with (self-)consciousness. When D'Allesandro says it, the disarmingly truthful *way* in which it is said (style) negates the camp interpretation. It just isn't funny. He wants to get away; he wants to be with beautiful women. And he wants to be with beautiful men. Straight.

Lonesome Cowboys 1968

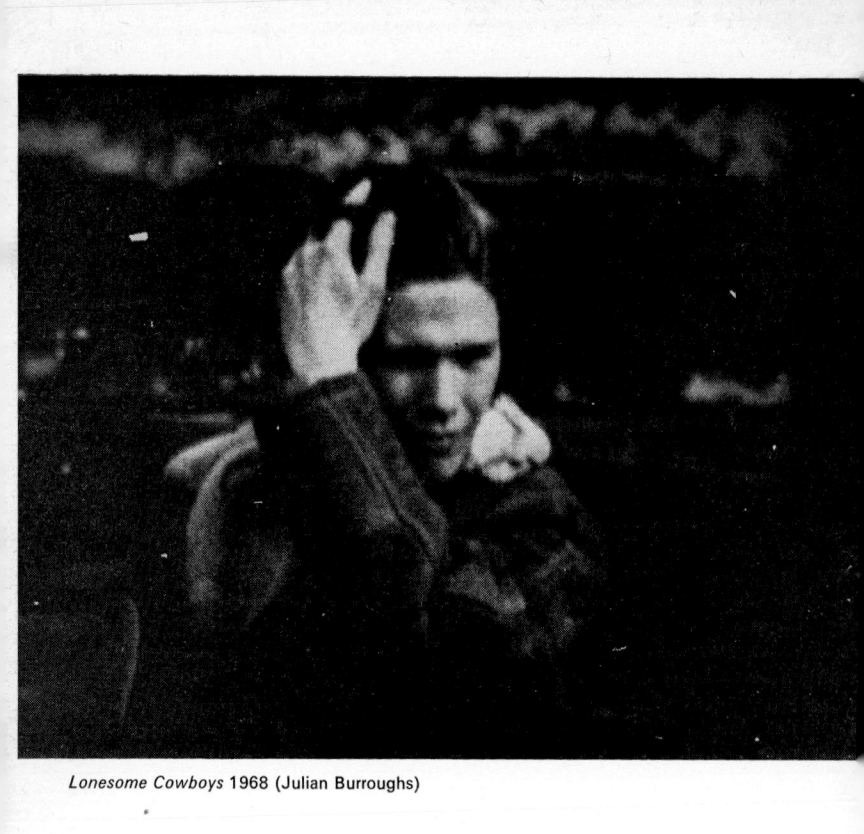

Lonesome Cowboys 1968 (Julian Burroughs)

To offset the campiness of the film, Warhol often (intuitively?) gives reaction shots. When one person says something (not only in humorous or camp situations), we see a several-second close-up of someone else, either listening or distractedly looking somewhere else, self-involved. The visual enfolding of one person, in counterpoint to what another person is *saying,* is one of Warhol's great cinematic strengths. Surface skin is enough to lead one into revelations about the 'other'. Unrelated movements, and nuances of feeling expressed through them, are the

Lonesome Cowboys 1968 (Eric Emerson)

beginning of a confrontation so overwhelmingly emotionally laden that for Warhol they suffice. The edge of a face and the edge of a cowboy hat, stared at for ten, twenty seconds, force the voice-over to recede in importance; the shocking immediacy of the film relies on such images, such sections of visible, human *shape.* When such a face is held by the camera in opposition to what is being said, the strength of image is all the more potent, thus its usage as a foil to camp/humour (sometimes).

In *Lonesome Cowboys* Warhol doesn't shy away from his film

aesthetic as seen in *Sleep, Empire, Blowjob,* etc. He expands our communication by fusing his long, still-camera microscopic close-up takes with the structure of macroscopic 'action' (riding horses, wrestling in the grass, dancing to *Magical Mystery Tour,* etc.). The minute detail however accidentally it may have been focused upon, is, for Warhol, of utmost importance. Its fusion with large-scale, open-space action is a brilliant step, and a risk. The risk here pays off: in *Lonesome Cowboys* we don't lose the sense of Warhol, we don't feel a sell-out to commercial technique. We realize, rather, his tenacity to take a specific aesthetic into a larger realm without fear of its destruction. In film, where every aesthetic becomes, after a time, watered down, shallow, over-used, misused, and ultimately meaningless, Warhol has taken his aesthetic all the way and come up with a fusion which does not deny his personal style/form/content. At the same time, he manages to use a common situation, rather than an eccentric one: the game of being a cowboy on the range. He chooses the most crucified subject-matter and remakes it, returns it to its mythical archetypal importance, but now as an alternative, as a radical ideal, not as a worn-out history.

SUPERSTARS: Viva loses her importance as an individual when she is raped (a brutal, social ambience); parodying 'feminine' helplessness, she screams for her Nanny (Taylor Mead!). Viva regains her importance as an individual, her strong sense of self and existential assertion of idiosyncratic personality, in the inter-personal confrontations with Taylor, Tom, and with the Sheriff.

As Marilyn's attraction was in the *self* that shone through, so Viva's self is what makes her a superstar, and the most incredible film person imaginable. Viva's is an aquiline beauty that is only one step from ugliness, and a soft fragility exciting in its ability to dominate the scene and not become shallow. When Viva *is* bored, we see it; but underneath lurks intuitive semi-consciousness, her internal coping mechanism for every film moment, making of every movement, even the yawns of boredom, an almost instinc-tive act of individual self-assertion. The superstar aspect of Viva is precisely the portrayal of her self at all times. In *Bikeboy* she can put down the bikey's masculinity in one fell swoop, 'You're not delicate enough.' But she means that without viciousness. She *can* be bitchy and domineering over the bikey too, though. The bitchiness does become apparent when she makes sly,

Lonesome Cowboys 1968 (Viva)

Bikeboy 1967 (Viva)

knowing faces to the camera (and those standing around out of frame), showing her disgust for the bikeboy's lack of worldliness, his naïveté, his very *oppression.* She puts him down for that. She is Viva the bitch. And she is gentle Viva when genuinely wanting to teach him how to kiss; she wants him to make love to her in a less cold, objective manner. In *Lonesome Cowboys* her self shows through most strongly when she sings *Kyrie Eleison* to Tom during the seduction, undressing him, getting him to fuck her, then dropping into her own secret fantasies, '. . . if you've been brought up to be a martyr, it's ingrained in you . . . it's too late to get out of it.' She lets go of reserve, betraying her vulnerability; that is the source of her beauty.

Bikeboy 1967 (Bikeboy, Ingrid Superstar)

Ingrid is the dumb-blonde superstar that Viva isn't: in *Bikeboy* she babbles on and on in a hilarious deadpan kitchen scene about her 'runny eggs', about eggs in general, about hundreds of uses to which eggs can be put: for salads, fried, frozen, mashed, etc. The dumb-blonde concept is sex under the guise of naïveté. It is perfectly enacted: when ketchup and fried eggs is the form (the verbal *exterior*) tits is the content (Ingrid's). She's talking to herself while Joe stands, bored stiff, light years distance from her, staring into space, into the camera, etc. He attempts to communicate facially to the camera, to us, implying he's above all her bullshit-verbalization, that she's really crazy and he knows it. But we and she know different. She is really dominating him;

by *not* acknowledging that she knows what she's doing, that it is part of an act. She isn't dumb; her repetitive obsession is a way of dominating the kitchen, the visual and verbal realm in this film segment. Marilyn Monroe wasn't dumb either. Suicidal yes, neurotic yes, but not dumb. The permutative experiential possibilities for boredom as enumerated by Ingrid's 'eggs' monologue, is the funniest Warhol sequence ever. It is akin to Beckett's formula of the obsessive neurotic repetitive enumeration of a minute chunk of reality. Beckett's 'Watt' enumerates possibilities (did he come, did he go, if he came, how, did he come then go, did he wait, did he come slowly, did he wait, then come? etc.). Ingrid enumerates, similarly, egg recipes (ham 'n eggs, bacon 'n-eggs, fried eggs, runny, no not runny eggs, eggs with carrot salad, eggs heated then fried, eggs drippy, eggs cold, eggs boiled, etc.).

SCRIPTING AND TIME: There's a vague idea, lots of shooting, and a precise editing unmatched by any Warhol film. Whether that editing is due largely to intuitive decision-making on-set or in the cutting-room is often hard to tell. There's a linearity to the film, from Main Street confrontation ('isn't that too much family-togetherness?!') to the final leaving the family ('the time has come for me to wander . . . here I am, being myself . . .'). A long-take lovemaking scene between Viva and Tom precedes the opening 'Cowboy' Main-Street start to the film itself. It is used as establishment of the Warhol viewpoint, the close-in look at bodies making love, the abstract familiarity of physical together-ness, the sectionalized human interaction both timeless and spatially non-specific. Then cut to the 'actual' film's start. From then on there's a chronological development of psychological time; that is, the *reasons* for actions are set forth (the tightly knit family finally breaking up, under the pressure of the outside world, the same pressures which also served to originally hold the tribal horde *together*). These motives towards action do not fit into chronological 'real' time as we are used to it in film. The drag scene with the sheriff could just as well come ten minutes earlier or later. As a whole, nevertheless, the order imposed on the structure, while permitting great in-take freedoms, seems (mainly in retrospect) to have given a unity to the film's statement, on the psychological and on the story level.

The scripting seems to be the bare essential outline of 'action', while the *people* take it from there; the control is largely exercised

Lonesome Cowboys 1968 (Viva, Tom Hompertz)

Lonesome Cowboys 1968 (Tom Hompertz, Eric Emerson)

after the event, as would fit logically with Warhol's concern. Time is at once real time (within each *take*) and film-time (the manipulation of the reels in an order imposed by the film-maker, not by actuality of *event*). The film's 'story' brings a much larger audience to it; but one suspects that the positive reaction the film often gets is due to its great humour, and not to many of the other concerns it deals with. Warhol has managed to cater to those whose reactions are so frustrating to him, while at the same time again taking on a no-compromise radical position, hard-headedly consistent. *Lonesome Cowboys* has been completely ignored by

Fuck 1969 (Louis Waldon, Viva)

the mass audience, for they have not yet learnt how to deal with such a film; they are still, for the most part, entirely manipulated by the products of the major distributors. Tough on them, tough on Warhol, tough on all of us.

page 148, Bikeboy 1967, filmstrip illustrating intercut technique—inserted sections from the cutting-room floor, added in the editing stage

page 149, Lonesome Cowboys 1968, filmstrip illustrating strobe cut technique—quick cuts in sound and picture, the result of flicking the camera switch on and off; intention to pull the viewer out from the screen life back into the viewer/voyeur reality, then to cut back into the 'story'.

Other things

Warhol creates in whatever medium he finds necessary. He wants to rent out friends of his. At 5000 dollars per week one can rent-a-friend, for anything one likes; the perfect slave, a companion. What one really wants is a rent-free friend, but of course Warhol's conception parodies people's so-called needs. The cynicism doesn't deny the reality which is being dealt in. The fact is that most of us would accept such a friend, if it weren't for the base association which money has (especially such a *large* sum). It's only for the rich who perhaps need it more *that* way, or can only get it that way anyway. Warhol promises more than just a friend for a week; he will sign any photographs taken, making 'art' of the results. Capitalism exposed. To exhibit the people there are halters tied around their waists and hung on to the wall, a not uncomfortable situation, but one which lucidly exposes them to the greedy buyers' eyes.

Silver is Warhol's favourite colour, so he dyes his hair silver. Silver makes things, so Warhol claims, disappear. His paintings are often silver-inked. He made some silver pillows, 'floating paintings' he calls them; balloons, named *Clouds*. Filled with helium, the huge, light, shiny objects float around a room, rest on the ceiling, almost touching or not. They *look* hard and metallic; they *feel* soft to the touch, giving. And when the helium runs out, as it inevitably does (unless they're freed to fly into the endless sky), the result is limp, impotent: the negation of the self through the image (among other things). Warhol is fixated by such self-destruction, negation of the symbol.

In the film *Blowjob,* we see a face, over and over, in sexual ecstasy (or at least, release). There's the obliteration of the image, all the more intense in that the person is reaching orgasm (we don't see the active partner in the sex-act). The psychical ego-dissolution of orgasm is bound up with the physical negation of the self through the leader-fogging filmic device. One reality plays over into the other, so that both are real; that which *is*, and that which is represented.

Another occasion of Warhol's symbolic self-negation is his sending of a double, Alan Midgette, on a series of college lecture tours 'by Andy Warhol'. In his *Andy Warhol's (Index) Book* there's an extension of this idea; a sheet of paper with the 'Andy

Clouds exhibition 2–27 April 1966
Leo Castelli Gallery, New York

Warhol' imprint. The instructions say, 'For a Big Surprise, place in a glass of warm water!' One does so. The name disappears.

'Doing things, keeping busy. I think that's the best thing in life, keeping busy. But they (the cops) think we're *doing* awful things, and we aren't.' His art is his person. 'I prefer to remain a mystery.' 'If you want to know all about Andy Warhol just look at the surface of my paintings and films and me, and there I am.'

A sense of frustration threads through much of Warhol's other structures. The *Dance Diagram: Tango* (1961) is a full-scale dance lesson floor diagram. One stands on it, follows the foot-markings, but in the middle of step number six, one searches for number seven in vain, left foot kept hanging in the air. Again, one isn't making it. A full stop ending to an action. A blank, in motion.

For a show in 1969 of artist's 'interpretations' of hatstands, Warhol just took the core of a hatstand and exposed a primitive totem, a phallic minimal sculpture, with old newspaper fragments stuck to a corner (probably used originally to tighten the fit). The result was pure Warhol, in concept, though in form completely new, unrecognizable. He put it on sale for 3¢. Of course the owners of the gallery where the exhibition was held bought it immediately (requisitioned would be the more appropriate word). The public didn't stand a chance; but then, according to Warhol, it was only worth 3¢ anyway.

A deadpan camera was used for a planned three-hour television piece which Warhol was going to be commissioned to do. He'd just record the (on video) comings and goings of friends, acquaintances, hangers-on. He'd record what 'happened', in a conceptually delineated sculptural space, using people for their event-iveness. Everyone has a specific individual reaction to the comings and goings of other people, but the structural overlay is there, making of it an 'Andy Warhol' situation. 'People are so fantastic, you can't take a bad picture' (or video).

In late 1969, Warhol's novel *a* was published. Among others, the *New York Review of Books* fumed. It's now out in paperback. It's the first novel not to have been read by its author. The novel relates one day in Ondine's life, a day that begins, so the flap assures us, with Ondine popping several amphetamine pills and ends, twenty-four hours later, in an orgy of exhausted confusion.

Dance Diagram: Tango 1961
Hessisches Landesmuseum, Darmstadt

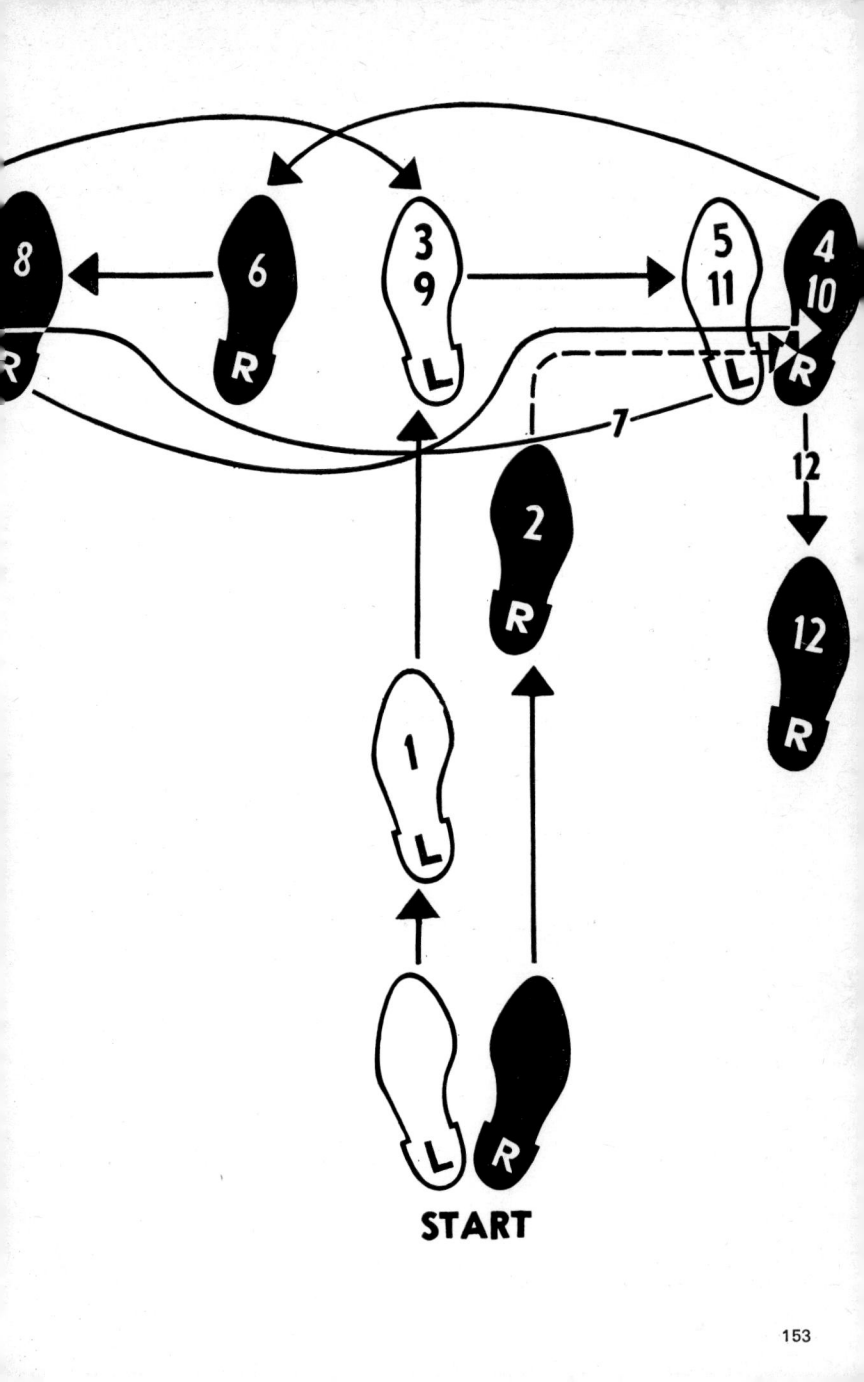

START

In between, 'anything is likely to happen in this one-day-and-night account of the "in" world of Andy Warhol'. The novel is straight transcription from a tape, of that day. Some poor secretary did the transcribing, and her mistakes aren't deleted. The boredom of the book is nothing if not real. The hypersensitive interactions between Rotten Rita, The Duchess, Billy Name, Ondine, Ingrid, The Sugar Plum Fairy, and Andy would seem sensational if related in a newspaper or magazine. So would an evening with Ondine in drag or an evening at a teenage whorehouse. In real life, it's just life itself, the passing of another day. Warhol's new novel is about to be published. It's title: *b*.

It doesn't matter that much. I always had this philosophy of 'It doesn't really matter.' It's an Eastern Philosophy more than Western. It's too hard to think about things . . . the war, the bomb, bother me, but there's not much you can do about them. I've represented it in some of my . . .

Untitled, 1969 9¼ in. h.
Collection Mr and Mrs Arne Ekstrom, New York

Acknowledgments

For film stills thanks to Enno Busman, West German Television, Cologne; Leo Castelli, New York; Steve Dwoskin, London; Paul Morrissey, New York; Stephen Shore, New York; Jimmy Vaughan, London. For the photograph on page 19, thanks to Martin Battersby, Brighton. The photographs on pages 26 and 79 are by Rudolph Burkhardt, New York; the photograph on page 68 is by Shunk Kender, New York; on page 79 by Eric Pollitzer, New York.

Index

Numbers in italics refer to pages including illustrations

STUDIO VISTA | DUTTON PICTUREBACKS

edited by David Herbert

British churches by Edwin Smith and Olive Cook
European domestic architecture by Sherban Cantacuzino
Great modern architecture by Sherban Cantacuzino
Modern churches of the world by Robert Maguire and Keith Murray
Modern houses of the world by Sherban Cantacuzino

African sculpture by William Fagg and Margaret Plass
European sculpture by David Bindman
Florentine sculpture by Anthony Bertram
Greek sculpture by John Barron
Indian sculpture by Philip Rawson
Michelangelo by Anthony Bertram
Modern sculpture by Alan Bowness

Art deco by Bevis Hillier
Art nouveau by Mario Amaya
The Bauhaus by Gillian Naylor
Cartoons and caricatures by Bevis Hillier
Dada by Kenneth Coutts-Smith
De Stijl by Paul Overy
Modern graphics by Keith Murgatroyd
Modern prints by Pat Gilmour
Pop art: object and image by Christopher Finch
The Pre-Raphaelites by John Nicoll
Surrealism by Roger Cardinal and Robert Stuart Short
1000 years of drawing by Anthony Bertram

Andy Warhol by Peter Gidal
Arms and armour by Howard L. Blackmore
The art of the garden by Miles Hadfield
Art in silver and gold by Gerald Taylor
Costume in pictures by Phillis Cunnington
Firearms by Howard L. Blackmore
Jewelry by Graham Hughes
Modern ballet by John Percival
Modern ceramics by Geoffrey Beard
Modern furniture by Ella Moody
Modern glass by Geoffrey Beard
Motoring history by L. T. C. Rolt
Railway history by C. Hamilton Ellis
The story of cybernetics by Maurice Trask
Toys by Patrick Murray
The world of Diaghilev by John Percival